F-P
Net
10—

SARGENT

Watercolors

SARGENT
Watercolors

by Donelson F. Hoopes

Published in cooperation with
The Metropolitan Museum of Art, New York
The Brooklyn Museum of Art, New York

Watson-Guptill Publications/New York
Phaidon/Oxford

Front cover: *Pomegranates, 1908*
Courtesy of The Brooklyn Museum
Purchased by Special Subscription

Paperback Edition, 1976

First published 1970 in the United States by Watson-Guptill Publications,
a division of Billboard Publications, Inc.
1515 Broadway, New York, N.Y. 10036

Published in the United Kingdom by Phaidon Press Ltd., Littlegate
House, St. Ebbe's St., Oxford

Library of Congress Catalog Card Number 70-120549
ISBN 0-8230-4641-9 (U.S.)
ISBN 0-7148-2368-6 (U.K.)

Manufactured in Japan

1 2 3 4 5 6 7 8 9/89 88 87 86 85 84

For Judie

ACKNOWLEDGMENTS

Sargent Watercolors is the second volume to be published by Watson-Guptill relating the American watercolor collections of The Brooklyn Museum and The Metropolitan Museum of Art. The first publication, *Winslow Homer Watercolors*, together with the present work, amply indicate the strength and diversity of interest which are the hallmarks of these two giants of American painting. And seen together for the first time, these superb watercolors reveal the rich concentration of the works of Homer and Sargent in the Brooklyn and Metropolitan museums. I am deeply appreciative of the cooperation given this project by the administrations of the two museums, particularly to Bradford D. Kelleher, Sales Manager, and Joseph Veach Noble, Vice-Director, The Metropolitan Museum of Art; and to Thomas S. Buechner, Director, The Brooklyn Museum. To John K. Howat, Associate Curator in Charge, American Paintings and Sculpture, go my thanks for his valuable assistance with the watercolors in the Metropolitan Museum's collection. To Sylvia Hochfield, Editor of Publications, The Brooklyn Museum, and to Donald Holden, Editor-in-Chief, Watson-Guptill Publications, I am especially grateful for suggesting and sustaining this project. I am indebted also to the staff of Watson-Guptill, principally to Lawrence C. Goldsmith, Managing Editor, to Heather Meredith for her careful editing of the manuscript, to Margit Malmstrom for her good work in co-ordinating the photography for the book. Geoffrey Clements provided the surpassingly fine color transparencies.

D. F. H.

CHRONOLOGY

1856. Born in Florence, Italy, January 10 or 12.

1857. Sister Emily born. (Died 1936).

1862. Sargent family moved to Nice, France.

1865. Sargent family continued its travels, including Pau and Biarritz. Sargent's first visit to London; then Paris, where he made his earliest drawings of animals in the zoological gardens.

1868. Sargent's first trip to Spain; visited Madrid. Sargent family summered in Switzerland; spent winter in Rome. Sargent sent to study in Rome at the studio of painter Carl Welsch.

1869. Family resumed its travels in the spring: Naples, Sorrento, Capri, Munich, and Carlsbad. Returned to Florence for the winter.

1870. Sister Violet born. (Died 1955). Sargent entered Accademia delle Belle Arti, Florence; drew from plaster casts of antique sculpture.

1871. Winter in Dresden; Sargent kept sketchbooks of travels.

1874. Family moved from Florence to Paris. In August, Sargent entered Ecole des Beaux Arts; transferred to the studio class of Carolus-Duran in October. Fellow students included Theodore Robinson, J. Carroll Beckwith, and Paul Helleu.

1875. Family moved from Paris to St. Enogat, Brittany; Sargent and Beckwith took a studio on Rue Notre Dame des Camps.

1876. Sargent met Monet at the latter's exhibition at the Durand-Ruel galleries, Paris. In May-August, family traveled in the United States. Established American citizenship. Back to Paris in October.

1877. Exhibited first Salon picture, *Portrait of Miss Watts*. Summer spent making preparatory sketches for *Oyster Gatherers of Cancale (En Route pour la Pêche)*, The Corcoran Gallery of Art, Washington.

1878. Entered *Oyster Gatherers of Cancale* in Salon exhibition; won Honorable Mention. Assisted Carolus-Duran with his mural decoration for the Louvre, *The Apotheosis of Maria dei Medici*. Works of Sargent and Whistler shown in United States for the first time at National Academy of Design, New York.

1879. Exhibited three paintings in Salon. Second visit to Spain; painted study of *Maids of Honor (Las Meninas)*, by Velasquez, in the Prado Museum.

1880. First visit to Morocco in January. Went to Holland in spring to study paintings of Frans Hals in Haarlem. Spent summer in Venice, taking a studio in the Palazzo Rezzonico.

1881. Entered four portraits in Salon exhibition.

1882. Exhibited *El Jaleo* (Isabella Stewart Gardner Museum, Boston), in Salon, and drew much critical attention. In Venice during late summer; painted street scenes and interiors. Traveled to Rome, Siena, and Florence during the fall.

1883. Sent *The Boit Children* (Museum of Fine Arts, Boston), to Salon. Moved to studio on fashionable Boulevard Berthier, Paris.

1884. Exhibited *Portrait of Madame X* (The Metropolitan Museum of Art), at Salon; portrait much criticised. Summer spent in England; rented studio near Albert Hall, London. In Winter returned to Paris; commissions declined because of Gautreau (*Madame X*) scandal.

1885. Moved to London; took studio adjoining Whistler's former studio in Tite Street. Edwin Austin Abbey introduced Sargent to the artists' colony at Broadway, Worcestershire; began to paint *Carnation, Lily, Lily, Rose* (The Tate Gallery, London).

1886. Henry James introduced Sargent to Mrs. John L. Gardner (Isabella Stewart Gardner). At Broadway in summer completed *Carnation, Lily, Lily, Rose*, the sensation of Royal Academy exhibition of 1887. Helped to found "New English Art Club," which championed Impressionist cause in England.

1887. To United States in September, at invitation of Henry Marquand, to paint portrait of Mrs. Marquand, the first of his American commissions. Exhibited twenty works in Boston, including *The Boit Children* and *El Jaleo*, at St. Botolph Club.

1888. Finished *Portrait of Isabella Stewart Gardner* in Boston, early in year. Spent summer at Calcot, England, with family. Painted landscapes, figure groups in modified Impressionist manner.

1889. Father died in April. Sargent awarded the title *Chevalier* of the Legion of Honor by French government; appointed to serve on the jury of the Salon. Joined Claude Monet at Giverny in early summer; painted landscapes together. Returned to United States in December, accompanied by sister Violet.

1890. Commissioned to paint mural decorations for a hall in the Boston Public Library, designed by McKim, Meade and White. To New York in February; painted portraits and exhibited at Society of American Artists. Traveled to Egypt in December to study ethnic types and ancient architecture for use in his Library murals.

1891. Travelled in Mediterranean area in summer. Returned to London in fall. Began work on the mural designs in studio at Fairford, Gloucestershire, which he shared with Edwin A. Abbey. Sargent elected Associate, National Academy of Design, New York.

1893. Nine Sargent paintings shown at Chicago World's Fair.

1894. Elected Associate, Royal Academy, London. Awarded Temple Gold Medal, Pennsylvania Academy of the Fine Arts, Philadelphia.

1895. Transferred his mural studio from Fairford to a studio on the Fulham Road, London. Sailed to Boston in April for installation of first sections of Library murals. Summer in Spain.

1896. Elected full Academician, National Academy of Design, New York; Royal Academician, Royal Academy, London; *Officier* of the Legion of Honor, Paris.

1898. Commenced series of portraits of the Wertheimer family, beginning with *Portrait of Asher Wertheimer* (The Tate Gallery, London), the London art dealer. Spent part of the summer in northern Italy; made studies of early Christian mosaics in Ravenna.

1899. 110 works exhibited at Copley Galleries, Boston. Consulted with Augustus St. Gaudens in Paris about problems in modeling maquettes for Library compositions. To Venice for summer; stayed with cousins, the Daniel Curtises, at Palazzo Barbaro. Painted important "conversation piece" of Curtis family, *An Interior in Venice* (Royal Academy, London).

1900-1902. Sargent's career as portrait painter reached its zenith. Summer trips to paint landscapes in Italy and Norway.

1903. Sailed for the United States with second set of murals for the Boston Library. Painted many Americans, including Theodore Roosevelt. Museum of Fine Arts, Boston, exhibited twenty portraits in the spring. Degree of LL.D. conferred by University of Pennsylvania. Sailed for Spain and Portugal in May; resumed portraits in London during the winter.

1904. D.C.L. conferred by Oxford University. Summer in Italy.

1905. To Palestine in December for further studies for Library murals. Death of Mrs. Sargent.

1906-1908. Growing dissatisfaction with portrait painting. Began protracted summer trips throughout Italy, Switzerland, and western Mediterranean, accompanied by friends and favorite students.

1909. Awarded the Order for Merit by France; the Order of Leopold of Belgium; LL.D. conferred by Cambridge University. Honors came at moment Sargent decided to abandon portrait painting.

1910-1914. During winter worked almost exclusively on Boston Library murals in London. Painting trips to Italy, Spain, and Switzerland.

1915. Exhibited thirteen paintings at the Panama-Pacific Exposition.

1916. Arrived in Boston from London in May, with further additions for the Library stair hall. Received second mural commission from Museum of Fine Arts, Boston, to decorate the rotunda. Accommodated a few Bostonians with portrait drawings in charcoal. Awarded LL.D. from Yale University; Doctor of Arts from Harvard University. Summer painting trip to British Columbia.

1917. Painted portraits of John D. Rockefeller and President Woodrow Wilson for benefit of the Red Cross. Visited James Deering at Vizcaya, Ormond Beach, Florida, painted brilliant watercolors there. Carnegie Institute, Pittsburgh, organized first joint exhibition of Sargent and Homer watercolors.

1918. Visited the war zone in France during the summer, as official war artist. Experiences resulted in one of his most important paintings, *Gassed* (The Imperial War Museum, London).

1919-1921. Worked on design for murals in the Museum of Fine Arts, Boston, whose themes were taken from Classical mythology. The rotunda installed in 1921; Sargent asked to provide further designs for the stair hall ceiling of the Museum. Last two elements of the Boston Library murals installed.

1922. Mural decorations for the Widener Memorial Library at Harvard University designed and installed. Sargent remained in Boston.

1924. Sargent departed the United States for the last time. Important exhibition of sixty oil paintings and twelve watercolors at Grand Central Art Galleries, New York. Sargent resumed work on his unfinished museum decorations in London.

1925. Painted two final portraits; that of Marchioness Curzon of Kedleston reaffirmed his command over portraiture. Completed final sections of Boston Museum murals were sent to the United States for installation. Died in London, April 15, just before he was to sail for Boston. Memorial services held in Westminster Abbey, on April 24. The completed Boston Museum murals installed and unveiled on November 3, 1925, in conjunction with a large memorial exhibition of Sargent's paintings and watercolors.

1926. Two memorial exhibitions held: The Metropolitan Museum of Art, New York; The Royal Academy of Arts, London.

BIBLIOGRAPHY

A Centennial Exhibition: Sargent's Boston. Introduction by David McKibbin. Museum of Fine Arts, Boston, 1956.

Birnbaum, Martin. *John Singer Sargent: A Conversation Piece*. New York, William E. Rudge's Sons, 1941.

Charteris, The Hon. Evan E. *John Sargent*. New York, Charles Scribner's Sons, 1927.

Downes, William Howe. *John S. Sargent, His Life and Work*. Boston, Little, Brown and Company, 1925.

Fenollosa, Ernest F. *Mural Paintings in the Boston Public Library*. Boston, Curtis and Company, 1896.

Hoopes, Donelson F. "John Singer Sargent and Decoration," *Antiques*, LXXXVI (November, 1964), p. 588 ff.

Hoopes, Donelson F. "John S. Sargent: The Worcestershire Interlude, 1885-89," *The Brooklyn Museum Annual*, VII, 1965-66, p. 74 ff.

James, Henry. *Picture and Text*. New York, Harper and Brothers, 1893.

Low, Will Hicok. *A Painter's Progress*. New York, Charles Scribner's Sons, 1910.

Meynell, Alice. *The Work of John S. Sargent*. London, W. Heinemann; New York, Charles Scribner's Sons, 1903.

Minchin, Hamilton. *Some Early Recollections of Sargent*. Letchworth, England, Garden City Press, 1925.

Mount, Charles M. *John Singer Sargent, A Biography*. New York, W. W. Norton and Company, Inc., 1955; London, W. W. Norton and Company, 1957.

Mount, Charles M. "John Singer Sargent and Judith Gautier," *Art Quarterly*, XVIII (Summer, 1955), p. 136 ff.

Mount, Charles M. "Archives of American Art: New Discoveries Illumine Sargent's Paris Career," *Art Quarterly*, XX (Autumn, 1957), p. 304 ff.

Mount, Charles M. "Carolus Duran and the Development of Sargent," *Art Quarterly*, XXVI (Winter, 1963), p. 396 ff.

Quilter, Harry. *Preferences in Art, Life and Literature*. London, S. Sonnenschein and Company, 1892.

Rothenstein, Sir William. *Men and Memories*. New York, Coward-McCann, Inc., 1931-40, 3 vols.

Sargent, Whistler and Mary Cassatt. Exhibition catalogue, introduction by Frederick A. Sweet. Art Institute of Chicago and The Metropolitan Museum of Art, 1954.

The Private World of John Singer Sargent. Exhibition catalogue, introduction by Donelson F. Hoopes. The Corcoran Gallery of Art, Washington, D.C., 1964.

John Sargent was born in Florence, Italy in 1856, the second of five children of Mary Newbold Singer and Fitzwilliam Sargent, of whom only he and two sisters survived to maturity. His mother, of a prominent Philadelphia family, believed that life in Europe was to be preferred over an existence in provincial America. Thus, she had persuaded her husband to abandon a promising career in medicine for the nomadic existence of wandering expatriates. They had arrived in Europe shortly after their marriage, when Mary Sargent had received a modest inheritance. On this small annuity she contrived to support her husband and children on a protracted Grand Tour. Usually, they were compelled to spend part of the winter in summer resorts, taking advantage of the off-season rates. In better times, they could summer at Biarritz, and spend the winter months in Florence or Nice. Henry James, the American novelist, a lifelong friend of Sargent, characterized them as living like ambassadors one year and paupers the next.

Sargent's natural aptitude for drawing was observed by his mother, who encouraged her young son to keep sketchbooks during their travels. The surviving books, many of which are now in the collection of the Fogg Art Museum at Harvard University, reveal a precocity in his observation of nature, especially in the rendering of atmospheric views of the Austrian Alps. In the winter of 1868, when the Sargents settled in Rome, John received his first instruction from a professional artist, a German-American landscape painter named Carl Welsch. In the autumn of 1870, the family returned to Florence, where the young John was enrolled in the venerable *Accademia di Belle Arte*. There he made careful charcoal drawings from the antique, and received his first systematic training.

During the years 1870-74, Sargent developed his skill with line. Hiram Powers, nearly seventy and one of the many illustrious figures who comprised the Anglo-American colony in Florence, predicted a glowing future for the young artist. Sargent's natural facility, from the first, was strengthened by a discipline of mind which insisted upon completion of each sketch before embarking upon another. This attitude to his work seems to have been imbued in him by his mother, who actively encouraged him to pursue art over the quite different view of Dr. Sargent. Finally, strong-minded as always, Mary Sargent had her way; the idea of a career in the Navy was discarded. In April, 1874, John Sargent wrote to a cousin, "The Academy in Paris is probably better than the one here and we hear that the French artists, undoubtedly the best now-a-days, are willing to take pupils in their studios."

Sargent seems to have lost no time in locating a suitable studio. It was probably Joseph Farquharson, an English painter with whom the Sargents had struck an acquaintance during the summer of 1868, who provided the reference. Farquharson had been one of the first students of Carolus-Duran, and it was to this studio on the Boulevard Montparnasse that Sargent brought his portfolio.

Sargent was eighteen years old when his family finally took up residence in Paris on the rue Abbatucci; it was the late summer of 1874. Paris was experiencing a tremendous upsurge of artistic expression following the Franco-Prussian War. In April, there had occured the first exhibition of the revolutionary group of painters who had been dubbed "Impressionists" by an outraged critic.

By October, after a brief prelude of examinations at the Ecole des Beaux Arts, Sargent had been formally admitted to the separate class of Carolus-Duran. For the Sargents, the choice of this teacher must have been predicated upon practical considerations. Portraiture would be a proper occupation for their son, and would insure some measure of future livelihood. The influence of the intense, suave, and accomplished Carolus decided the course of Sargent's career. Not only did Carolus impart to him a thoroughly solid and painterly technique, but he also focused Sargent's talent upon portraiture.

Early in his career, Charles Auguste Emile Duran had styled himself "Carolus-Duran." His success was by no means immediate. In 1866, at twenty-nine, he was still an unknown, struggling for recognition. However, that year one of his paintings was acquired by the Lille Museum, and with this, Carolus marked the turning of his fortunes. After a trip to Spain, where he absorbed all that he could of Velasquez, Carolus returned to France and rapidly rose to the position of portraitist to the fashionable society of Paris.

The essentials of Carolus's art were a detachment, a cool elegance, and an economy of means that placed the subject firmly before the viewer. He offered no opportunity for penetrating the character of his subject and did not comment on what he could not see. Carolus believed that, "in art all that is not indispensible is harmful," and upon this premise his instruction was founded. He was influenced by the works of Velasquez and Courbet. His approach to painting was methodical and direct: "Find the middle tones, lay in the dark accents, and then, finally, the highlights." Carolus encouraged his pupils to make copies of the masters in the Louvre. However, copying did not mean bland imitation, but improvisation. No one was permitted to work over a copy; it had to be done *au premier coup*. Moreover, it was the matter of correct values in painting that, for Carolus, constituted the art. He was a product of what the critic George Moore had in mind when he wrote, "In 1830 values came upon France like a religion. Rembrandt was the new Messiah, Holland was the Holy Land, and disciples were busy dispensing the propaganda in every studio."

When Sargent entered Carolus's studio, the American was a

relatively shy youth, quiet in manner, and industrious in his work. The other American students included J. Carroll Beckwith (1852-1917) and Will H. Low (1853-1932), with whom Sargent made lasting friendships. Sargent quickly became the favorite of the master; yet, because of Sargent's obviously superior talent, together with his modest disposition, the newcomer found that his special status was accepted by all. His personal attachment to Carolus seems to have been close from the beginning.

On his own in Paris for the first time, Sargent took a room in a pension on the Boulevard Montparnasse, at an easy distance from the studio. While continuing under Carolus, he obviously was alive to the ferment of artistic activity abroad in the French capital. In April, 1876, he visited an exhibition of Impressionist paintings, where, for the first time, he saw the works of Claude Monet. Monet's eighteen canvases were among the second group exhibition of the Impressionists, held at the Galerie Durand-Ruel. The fluid style of painting advocated by Carolus was flexible enough to blend with other influences, and Monet's light and color-filled pictures made a powerful impact upon Sargent.

In May, 1876, Sargent made his first trip to the United States, accompanying his mother and his sister Emily. At twenty-one, he was able to establish his American citizenship, a status which he firmly maintained thereafter against the inducements of foreign honors, and in spite of a lifetime spent abroad. In Philadelphia, he visited the Centennial Exposition, and he made the rounds of the fashionable resorts of Saratoga and Newport, of which his mother was so fond. Back in Paris in the fall of 1876, Sargent established himself in a small and primitive, but adequate, studio on the rue Notre Dame des Champs, which he shared with his friend Beckwith.

Although there is no specific evidence to show that Sargent was influenced by Whistler at this time, the stylistic similarities apparent in his work certainly suggest it. Undoubtedly, an American artist with the stature of Whistler could hardly have escaped the notice of this highly impressionable and precocious student. However, the alchemy of Carolus's studio effected the greatest change. From a relatively shy youth, Sargent had become self-confident and somewhat worldly under the master's spell. If a choice was made deliberately between joining the group of independent artists, which included his friend Monet, or adhering to the realist establishment, represented by Carolus, Sargent seems to have decided in favor of the latter. To the Salon of 1877, he submitted a painting for the first time. It was the *Portrait of Miss Watts*. Either through its own appeal to the jury of selection, or through the influence of Carolus, the portrait was accepted.

The enormous strides Sargent was making can be measured by his capture, at twenty-two, of an Honorable Mention in the Salon of 1878. His entry, *The Oyster Gatherers of Cancale* (The Corcoran Gallery of Art, Washington, D.C.), won him this distinction. It represented Sargent's first success in the official art world, and qualified him to enter the Salon exhibitions thereafter without being required to submit to the jury of selection. The picture was realized from a series of oil sketches made on the Brittany Coast during the summer of 1877. While the finished version was painted in the studio, the scene is treated with fidelity to the *plein air* effects of truly observed light and color in nature. This is the first instance in which Sargent evidenced a definite departure from the style of Carolus-Duran in a work destined for the Salon. He was gradually gaining independence, and it is significant that he chose a landscape subject with which to begin proclaiming his identity. Moreover, the luminist color employed in the painting reveals Sargent's enthusiasm for the Impressionists, at a time when this group was being excluded from the official Salons.

It was in 1879 that Sargent began to emerge as a portrait painter in his own right, and his connection with Carolus's studio class became more tenuous. Still, Sargent was a comparative newcomer to this highly competitive field, and he needed the favor and good offices of his mentor. In the summer of 1879, the young American painted a portrait which combines the technical handling of the figure in the Carolus manner with an unexpected landscape treatment, thus injecting some of his own personal approach.

One of the solid principles taught in Carolus's studio was that of seeing and painting directly. Rapidity of execution, so necessary to the portrait painter, was thereby developed. The general studio method of copying from the old masters was not a routine or laborious chore with Carolus, but was regarded as a challenge to skillful improvisation. Velasquez was the god of the studio, and, in the fall of 1879, Sargent journeyed to Spain in order to study from the great examples in the Prado. For the first time in his career, he paused to study the work of Velasquez without the intermediary personality of Carolus. Only a few original efforts came out of this visit to Spain; instead, we have a number of important works by the Spanish master freely transcribed by Sargent, who continued to employ the *au premier coup* method of attack instilled by Carolus.

Music had always been an important part of Sargent's life. He was accomplished enough in later years to be able to play piano duets with Arthur Rubinstein, and, during his travels in Spain, he collected Spanish folk songs for his friend, the English writer Vernon Lee.

Music as a theme pervades two important works whose origins can be found in the Spanish journey of 1879. The earlier of the two, *The Spanish Dance* (Private Collection), shows the influence of the

works of other artists. The general disposition of the figures in the raking light, and the square format of the canvas, are reminiscent of Velasquez. However, the more important similarity seems to be to Whistler's *Nocturne in Black and Gold—The Falling Rocket* (Detroit Institute of Art). In July, 1877, Whistler exhibited this painting at the Grosvenor Gallery in London, and began his tragic exchange of verbal hostilities with the English critic John Ruskin. The famous lawsuit that followed ended in Whistler's bankruptcy in the spring of 1879. Surely a painting that occasioned their remarkable chain of events would not have gone unnoticed in the Paris art world. Additional suggestion of Whistler's influence may be found in the comparison of certain of his landscape pieces, such as *Cremorne Gardens, No. 2, ca. 1875* (The Metropolitan Museum of Art), with Sargent's study of twilight, *In the Luxembourg Gardens* (The Philadelphia Museum of Art), 1879. The similarities that exist between each of these two sets of paintings are so striking, and for Sargent, so specifically limited to this one brief period of his career, that the suggestion of Whistler's touch upon the younger painter seems convincing.

The second, and much larger, Spanish musical subject is *El Jaleo* (Isabella Stewart Gardner Museum), for which Sargent made a number of preparatory sketches. No doubt his love for the music and dance of Spain had led him to an evening's entertainment in some *bodega,* and by chance gave him the initial idea for *El Jaleo.* Manet had created a taste for the Spanish *mystique* when he exhibited his paintings of Spanish dancers in 1863. Baudelaire was so struck by his *Lola de Valence,* that he wrote a quatrain to her, comparing her charms to a glittering jewel. When, in 1890, Sargent encountered the famous Spanish dancer, Carmencita, in New York, he painted her in a manner that recalls both Manet and Baudelaire. However, *El Jaleo* remains his most ambitious effort at *genre* painting, and has been called his most imaginative picture.

Sargent visited Venice for the first time in the late summer of 1880, and took a studio in the Palazzo Rezzonico, then available for such purposes. But it was not until the summer of 1882, when he was invited to stay with his cousins, the Daniel Sargent Curtis family, late of Boston, that he made any significant use of the Venetian cityscape. His contemporary in the Curtis home on the Grand Canal, the imposing 15th-century Palazzo Barbaro, was Ralph W. Curtis. Together, they painted street and canal scenes and interiors. The cavernous rooms of the Barbaro and Rezzonico offered more than a passing suggestion of the spaces which Velasquez rendered in his scenes of court life in the palace of Philip IV.

The year 1883 was a turning point in Sargent's career; he had acquired a larger and more comfortable studio on the Boulevard Berthier. He left Montparnasse and student life with high expecta-

tions for a bright future in his new and fashionable quarters. He had become a regular exhibitor in the Salons and his progressively daring entries succeeded in establishing his identity as a rising young talent.

Probably toward the end of 1882, Sargent began work on the largest portrait he had attempted, a canvas nearly ninety inches square, *The Daughters of Edward Darley Boit* (Museum of Fine Arts, Boston), fully revealing the powerful influence of Velasquez. The portrait of the Boit children is Sargent's masterpiece of the *portrait d'apparat;* the girls are painted as if in their natural setting, where a feeling of informality pervades. Favorable reviews at the Salon exhibitions could help an aspiring artist attract clients, but Sargent had taken a large step by moving to the fashionable and expensive Boulevard Berthier studio. This move was not being justified by the number of portrait commissions that he had been able to obtain. For all of the invention and daring of *Madame Edouard Pailleron, The Boit Children,* and *El Jaleo,* he was still struggling for a living. Keeping busy between times, he created a gallery of portraits of friends and neighbors.

Sargent's career in Paris culminated in the dramatic episode of the exhibition of *Madame X* (The Metropolitan Museum of Art), at the Salon of 1884. He probably met the celebrated Virginie Avegno Gautreau, its subject, in 1881, either through one of his sitters or at one of the salons of the artistic or literary circles which he frequented at that time. Sargent became greatly attracted to her, and sometime in 1882 enlisted the aid of a mutual friend to broach the question of posing: "I have a great desire to paint her portrait and have reason to think she would allow it and is waiting for someone to propose this homage to her beauty. If you are 'bien avec elle' and will see her in Paris you might tell her that I am a man of prodigious talent." Sargent quickly established the primary idea for the lady's portrait; it would stress her exotic coloration and elegant profile. He continued work on it during the summer of 1883 at the Gautreau house in Paramé on the Brittany coast, near St. Malo.

The picture was still unfinished when Sargent brought it back to his Paris studio at summer's end. He continued to struggle with minute and exacting changes in the drawing and local color. This portrait was a daring concept: it aimed at realism while nearly eliminating the illusion of three dimensions in the modeling of the face and figure; it relied on vigorous line to convey the sense of life in the subject.

Sargent had created an image which at one stroke became a canon of worldly elegance while remaining an objective representation of a notorious professional beauty. The implications of his candor could not have escaped him. This painting was yet another

assault upon the Salon; its daring must surely have been calculated. At the last possible moment, Sargent decided to repaint the portrait on a fresh canvas. The laborious alterations which he had made on the original told too much about the struggle of its creation. He began a replica, painting it *au premier coup* as he had done often before. The replica was still unfinished when the movers came; the Salon was at hand and Sargent was obliged to send the overworked original.

In deference to the privacy of the subject, the Salon catalogue entry read, *Portrait de Mme.* . . . It was a useless gesture. The outburst of public indignation and derision that attended the viewing of *Madame X* on opening day shook Sargent to his roots. Both the public and the press reacted with shock, and only a few saw the modernity implicit in the portrait's startling realism. The uproar was, as Henry James wrote, ". . . a kind of unreasoned scandal—an idea sufficiently amusing in the light of some of the manifestations of the plastic effort to which, each year, the Salon is sponsor."

The consequences of the Gautreau *scandale* were not immediately felt. Shortly after the opening of the Salon, Sargent went to England on holiday, returning to the Boulevard Berthier studio at the end of the summer. The steady procession of clients that he had envisioned remained a dream, for the portrait of Mme. Gautreau had not only given him his fullest reception at the Salon, but it had also succeeded in driving away all of his prospective sitters. *Madame X* had proved to be an ordeal by fire, and Sargent emerged from this experience matured in the ways of the world: to be a successful portrait painter was not necessarily to exercise his full unbridled powers. Clients were not interested in having their characters revealed to the world when only a likeness was required.

Sargent's move to England had been prepared by a number of fortuitous meetings in Paris, notably with Mrs. Henry White, whose husband, shortly thereafter, became American Minister to The Court of St. James's. Probably through her Sargent met Henry James, who was already a celebrated literary figure. The two seem to have established an immediate rapport. The portrait of Mrs. White, painted in the Boulevard Berthier studio in 1883, came to hang in the White's London residence on fashionable Grosvenor Crescent after being shown at the Royal Academy exhibition of 1884. This strategic position helped to expose Sargent to the circles of English society who eventually became his avid clientele. James proved instrumental in his turn by introducing Sargent to the London literary and artistic scene; and later, in 1887, wrote a very glowing article in *Harper's Magazine* that served to introduce the young painter to America.

By the summer of 1885, the gradual break with Paris became an accepted necessity in Sargent's mind. England seemed to offer prospects for his career, and rescue from the desolation that engulfed him following the uproar over *Madame X*. When Sargent arrived in London, he established himself at The Arts Club in Hanover Square and set about prospecting for a suitable studio. Among the lodgers at the Club was Edwin A. Abbey (1852-1911), who had admired Sargent from a distance, at least since the preceding year. Probably inspired by Abbey, who had friends summering in the country, Sargent decided to sample the pleasures of rural England. Together, they proceeded upon a boating excursion on the Thames from Oxford to Winsor, and in September found themselves in Broadway, Worcestershire, some twelve miles south of Stratford-on-Avon. There they joined a group of American artists and their families, including Francis Davis Millet (1846-1912), Edwin Howland Blashfield (1847-1920), and the poet Edmund Gosse (1849-1928). Millet, his wife and children occupied Farnum House, described by Gosse as a medieval ruin. It was here that the group spent their days writing and painting.

Sargent returned to *plein air* painting once more. Gosse, ever observant, and utterly fascinated by Sargent's general demeanor, described the typical Sargent method of attacking the problem of landscape painting that summer: "He was accustomed to emerge from the house carrying a large easel, to advance a little way into the open, and then suddenly to plant himself down nowhere in particular, behind a barn, opposite a wall, in the middle of a field. The process was like that in the game of musical chairs . . . His object was to acquire the habit of reproducing precisely whatever met his vision. . . ." Gosse was observing Sargent's aversion to the academic concern for subject matter and composition, which, in the overemphasis then so prevalent among French and English academicians, robbed the art of painting of vitality.

What Sargent was doing in 1885 was to be explored six years later in Monet's celebrated *Haystack* series; that is, that the effects of light and color in painting should be put to the service of representing the true appearance of objects in nature. Sargent believed that it only hampered the artist to become absorbed with the substances of which those objects were actually formed. In this he was entirely opposed to the teachings of John Ruskin, to which the Academy still adhered tenaciously. Sargent embraced the new realism which affirmed the primary fact of a painting—it was not the object itself, but the total effect of the artistic translation in terms of pigment that counted in art.

Although Sargent was not in accord with the standards with which the Royal Academy ruled English art, he did not stand aloof from its exhibitions. His first appearance in the annual shows occurred in 1882, when he submitted a full-length portrait of his friend, Louise Burckhardt, *The Lady with the Rose* (the Metro-

politan Museum of Art). From that time until his permanent move to London he continued to submit occasionally; these were envoys certain to win him acclaim, such as his grandly conceived portrait, *Mrs. Henry White* (Corcoran Gallery of Art, Washington, D.C.), and the impressive group of three sisters (his first of the "Three Graces" theme), *The Misses Vickers* (The Sheffield Art Gallery and Museum, Sheffield, England).

In 1884, he had also exhibited in the newly founded Grosvenor Gallery; but with that establishment's rapid surrender to the influence of The Royal Academy, Sargent turned to The New English Art Club. The Club was founded in 1886 by a group of some fifty dissident young artists. Its more notable members included George Clausen (1852-1944), Philip Wilson Steer (1860-1942), Walter Richard Sickert (1860-1942), and John Lavery (1856-1941), all of whom had the experience of being students in Paris, many with Jules Bastien-Lepage (1848-1884). Their common bond was an admiration for French painting and a strong desire to establish a young, independent voice in English art. Although London was the first to see Impressionist paintings outside of France—Durant-Ruel opened a gallery in New Bond Street in the early 1870's—the critics, collectors, and public alike consistently regarded this kind of painting as a foreign extremist craze. As late as 1905, Durand-Ruel was again in London trying to create an interest for Impressionist paintings. This time, he staged a huge exhibition of 315 paintings, including Manet's *A Bar at the Folies-Bergère,* but only a few works were sold.

The years 1888 and 1889 found Sargent deeply influenced by Monet and, during this brief period in his career, he produced his most thoroughly impressionist paintings. Notable too, is the relaxing of his attitude toward subject matter. Even when painting his friends and family amid the lush verdure of the English countryside, Sargent became totally absorbed in light and color.

About 1887, he resumed an old interest in watercolor painting, stimulated perhaps, as Charteris suggests, by his meeting with Hercules Brabazon (1821-1906). The Frenchman was known, especially, for small and brilliant romantic watercolor views of Venice. Brabazon's approach to watercolor lay in the subtle omission, that suggested more mood than description. It seems doubtful that anything more than a professional acquaintance was established between the two in view of the fact that Sargent's portrait of Brabazon, painted in 1900, is dedicated, simply, "To Mr. Brabazon." Had he been more than an acquaintance, Sargent surely would not have been so formal.

Sargent's statements in watercolor at this time are not the *brio* performances so characteristic of his later work in the medium. It was not until the years following the turn of the century that he made any concentrated effort in watercolor; it served him well on the frequent summer holidays in Italy, in the Alps, and on his excursions to the lands bordering the eastern Mediterranean. Watercolor became more than a tool for sketching in Sargent's hands. His only peer in American watercolor painting is Winslow Homer.

As Sargent had taken useful instruction from Carolus-Duran, so he used Impressionism for his own purposes. In June, 1889, Sargent went to Paris for the opening of the International Exposition, where his work was represented by six portraits in the United States section. The exposition grounds were full of exotic sights and sounds that appealed to his innate, if submerged, taste for the fantastic. Here he encountered the tempestuous dancer La Carmencita for the first time; and here, also, he created a series of some half dozen extravagant costume pieces of the Javanese dancing girls. The color in these large studies vibrates with a new richness. They are life-size figures, painted in the attitudes of their native dances; and because Sargent did not see them as mere picturesque curiosities, but took genuine delight in the profusion of pure color these models offered, the *Dancers* seem alive rather than artificial.

Before returning to England that summer, Sargent spent a few days with Monet at Giverny. A little outdoor conversation piece, *Claude Monet Painting at the Edge of a Wood* (The Tate Gallery), shows the artist and his wife represented in a very rapidly executed canvas. Sargent looked over his friend's shoulder, as it were, and the technique employed in this work is generously laden with Monet's fluid manner. Although the pictures Monet was producing exerted a strong pull on Sargent's style, left to his own devices, Sargent gravitated toward the broad, incisive approach to painting. As the years passed, so did the Impressionist influence, and from 1890 forward, Sargent created his own method. Nevertheless, echoes of Monet are to be found in his last works.

Sargent remained fairly inactive as a portrait painter as far as the world outside his own circle of friends was concerned, in spite of continuing efforts to interest the English in his work. Then, suddenly, in 1887, he received an invitation to paint the portrait of the socially eminent Mrs. Henry Marquand of Newport, Rhode Island. He embarked for the United States in September, secure in the knowledge that his reputation had been growing steadily there thanks to a few paintings (*El Jaleo* among them) which had been bought by Americans from the Salons and from his studio. The glowing account of his abilities, recorded in the October 1887 issue of *Harper's Magazine* under Henry James's signature, was especially well timed. The article was being read by the American public as Sargent began work on the portrait of Mrs. Marquand.

Later, he traveled to Boston where an exhibition of twenty canvases, shown in the early winter of 1888, was enthusiastically received. Again, in *Harper's Magazine*, Henry James had some kind and perceptive words for the young artist.

It was through James, also, that Sargent was introduced to Mrs. John Lowell Gardner, better known in her adopted Boston as "Mrs. Jack." Isabella Stewart Gardner had persuaded James to take her to Sargent's studio a year earlier when she was visiting London. Her purpose was to see *Madame X*, then hanging in Sargent's house in Tite Street. She was determined that she would be painted in a like fashion, and when Sargent finally arrived in Boston in the winter of 1887-88, one of his tasks was to tackle this commission. The sittings took place in Mrs. Gardner's house on Beacon Street.

Appropriately enough, a background design was chosen for the portrait from one of the objects in Mrs. Gardner's growing collection of fine and decorative art objects, a cut velvet brocade panel. Later, Sargent himself was to become very well represented in the Gardner collection. In 1914, Mrs. Gardner destroyed the music room in her Venetian *palazzo*, Fenway Court, in order to build a "Spanish cloister" for *El Jaleo*. Throughout the years of their friendship, she and Sargent exchanged letters frequently. Occasionally, he volunteered to purchase an object for the collection at Fenway Court. In 1922, when he was in Boston for the last time, he painted the small watercolor, *Mrs. Gardner in White*.

During his first trip to America, Sargent had been introduced to Charles Follen McKim of the illustrious architectural firm of McKim, Meade and White, in New York. It was due to their meeting that Sargent was given the first of his Boston mural decoration projects—a design for installation in the Public Library on Copley Square. Upon his second trip to America in 1890, the formal commission was drawn up. The new McKim, Meade and White building would also include decorations by Edwin A. Abbey, and the then highly esteemed French neo-classicist Puvis de Chavannes (1824-1898). Sargent's association with America grew progressively stronger from this time forward. In the Library murals, he realized the culmination of his talents as an artist, and saw how he might carry his career beyond portrait painting into something new.

The second visit to America produced more than forty portrait commissions. Meanwhile, when the sitters were not keeping him occupied, Sargent's brimming energies brought forth paintings made purely for his own pleasure. He was beginning to taste the full flavor of success and to enjoy life to an extent he had not known before.

With the Boston Public Library decorations now occupying his energies, Sargent began to plan for the space he had been assigned in the building. His first thought was to develop designs around the theme of Spanish literature. This was discarded in favor of a more ambitious scheme, the origins of Western religion, and the rise and triumph of Christianity. In the autumn of 1890, Sargent and his family returned to Europe, and by Christmas they were located in Cairo. The study of archaeological remains could have been carried out in the great museums of Western Europe, but Sargent could only reconstruct the ancient world in his mind by actual contact with history. In addition, it was important to him to observe the people of modern Egypt because such studies would lend authenticity to certain racial types that he intended to incorporate into his decorations. In the studio which he had rented in Cairo, he painted one of the few nudes attributed to him, *The Egyptian Girl* (Private Collection).

All of his Near Eastern sketches were transported back to England, where they eventually became part of the first section of the grand design. Sargent found it necessary to remove himself from London in order to better concentrate on the enormous task before him. Together with Edwin A. Abbey, he shared a studio at Fairford, Gloucestershire. Here, such complicated designs as the first ceiling decoration depicting Astarte, the Semitic goddess of fertility, were brought to completion, along with other decorations for the north end of the hall in Boston. This group included the section known as the *Frieze of the Prophets*. The frieze has never accommodated itself into the spirit of the other decorations. It is far too literal. In comparison, the bold and energetic treatment of the preparatory sketch appears superior to the finished mural. The first sections were installed by December, 1985. However, Sargent was to labor on the enormous project for almost twenty-five more years.

Sargent always returned from his travels to London, and if any home existed for him, it was the house-studio in Tite Street. His fortunes had improved vastly during the 1890's and he was living well, though not ostentatiously. His circle of acquaintances included the important intellectual personalities of the day. Honors were now pouring down upon him. In one year, 1897, he was elected to the National Academy in New York, to the Royal Academy in London, and made an officer of the Légion d'Honneur of France.

Each of these honors was valuable recognition; paradoxically, however, as the portrait commissions flowed effortlessly into his studio, Sargent manifested a growing disillusionment and discontent with his work. As his resentment grew towards the lines of English Peers and American tycoons who wanted the touchstone of a Sargent portrait, fashionable clients became "mugs" to him.

These subjects did not appeal at all to the artist in him. After 1908, the record of the commissioned portraits shows an abrupt decline, and from this time forward Sargent focused his attention upon the protracted decoration of the room in the Boston Public Library. A rare note of bitterness attended this transition in his career: "No more portraits whether refreshed or not. I abhor and abjure them and hope never to do another especially of the Upper Classes. I have weakly compromised and lately done a lot of mugs in . . . charcoal and am sick of that too, although occasionally the brief operation has been painless." By 1909, Sargent had created nearly five hundred recorded portraits.

Those who came in close contact with Sargent found him to be a man of great vitality whose curiosity about the visual world remained unabated. For three memorable years, he taught at the Royal Academy School (between 1897 and 1900). One of the precepts he gave to his students was to "cultivate an ever continuous power of observation." He was always willing to try his hand at something new. In 1887, he provided his friend Alma Strettel with six illustrations in monochrome oil for her *Spanish and Italian Folk Songs*; ten years later, when a group of artist friends told him of their project to illustrate a new edition of the *Holy Bible*, he joined in, choosing the life of David as his theme. The project collapsed and his four monochrome oils were never used. Then, in 1895, Sargent turned his attention to lithography, probably stimulated by the great stir of interest in the medium that year, which was the centennial of its invention, marked by a special exhibition in Paris.

The decade of the 1890's saw profound changes in the tempo of Sargent's life. His travels now took him frequently to the United States in order to work on his Library decorations; he visited Africa, the Near East, Greece, and Italy in search of inspiration for the decorations. London, with its succession of portrait commissions, and Fairford, where the decorations were taking shape, vied for his attention. With the same gusto with which he enjoyed life, Sargent ceaselessly applied himself to drawing or painting even while combating the rigors of travel or while on some pleasant holiday. If he had been known to say, at the Academy school, that one could not make *enough* sketches, he carried out his precepts with a furious diligence. While the total production shows that often he was simply occupying the otherwise empty hours of a languorous Venetian afternoon, his compulsive habit of sketching often brought forth exquisite landscape and genre subjects.

While Sargent had employed the watercolor medium from time to time before the turn of the century, he had not used it with any degree of regularity until about 1900, when his travels became frequent and prolonged. When he painted his highly abstract vision of the banqueting hall in the Palazzo Clerice in Milan in 1904, Sargent had been studying its Tiepolo ceilings and found the complicated design too challenging to resist. Here the transparent washes are perfectly suited to his aims, although, in point of execution, the study seems stiff. But, by about 1905, Sargent seems to have dispensed with the last traces of hesitancy.

During the winter of 1902-3, the second set of decorations was installed in the Library, Sargent again presiding at the final placement. Now that the two ends of the great hall were filled, the empty expanse of the barrel-vaulted ceiling, lunettes, and walls all the more insistently called for completion. In the winter of 1905, Sargent made yet another trip to the Holy Lands, in an attempt to gather fresh inspiration for completing the Library project, now some ten years in progress. The accounts of this trip indicate that he had no fixed idea of what he wished to accomplish, and that what he gathered was not very much to the point. By this time travel was a matter of habit and the one sure form of escape from the demands of his titled sitters in London. As if rejoicing in his liberation, he painted the Mountains of Moab, and the Plains of Esdraelon in Palestine. In the watercolors, the peasants, fishermen, and goatherders are seen through a blinding light as abstract shapes and colors. When the light flooded his eyes as in *Mending a Sail*, the color sings in high key, and the swift, sure notations of the figures are perfectly adjusted within the tightest possible range. The cool interior of *An Arab Stable*, with its silvery grays and tans, seems to offer respite from this visual excitement.

From this time forward, Sargent's holiday trips to Italy, Majorca, Spain, and Corfu took place regularly nearly every summer and extended into the early fall. He never travelled alone on these Mediterranean jaunts, but surrounded himself with amiable friends and relatives. The majority of the oils and watercolors he painted on holiday between 1900 and 1914 share a mood of abandonment and a kind of sensual relaxation. Contrasted with the formal portrait commissions, the scenes of figures in attitudes of languid ease indicate the degree of Sargent's disaffection from his regular vocation in London.

Of all the places that Sargent loved to paint, none produced more inspiration for scenes of calm and relaxation than the area where the Alps are shared by the borders of France, Italy, and Switzerland.

Throughout his career Sargent persisted in one curious attitude —that of conceiving of an important exhibition painting in terms of size. Most of the casual, small sketches were never shown in exhibitions during the artist's lifetime, nor did he intend them to be more than objects for his own pleasure. Perhaps his early successes with pictures such as *El Jaleo* instilled a subconscious cor-

relation in Sargent's mind between size and the relative importance of a work to his career. Sargent spent part of the summer of 1913 at San Vigilio, on Lake Garda, where he made a large group of studies of fishing boats anchored in the small, walled harbor. Between 1913 and 1919, he worked on a large exhibition painting, incorporating the notes into a scene of almost theatrical proportions. *San Vigilio* (Lord Beaverbrook Art Gallery, Frederickton, New Brunswick), a huge canvas nearly nine feet in width, lacks the charm of the less self-conscious studies from which it was created. The reaction to its appearance on the walls of the Royal Academy in 1919 indicated that the chief enjoyment derived from the work was seeing how the artist had solved difficult pictorial problems. But Sargent's art had many facets, and was capable of seeming contradictions and surprises.

In his personal relationships, Sargent was not given to demonstrative expression of his inner feelings; he also tended to reserve expression within his art. Criticism of his painting, especially of some of the less sympathetic of the commissioned portraits, pointed to the offending flaw: "His art is all nerve and intelligence, but it is only mind deep; there is little heart in it. . . . Sargent, despite his final episode as a landscapist, must stand simply as the consummate international expression of the school of the well-painted bit." Yet, even while he was approaching art with a modified, but Impressionistic technique, as Mather remarked, with the "zest of a beginner," Sargent created some undeniably poignant portraits, deeply touched by a spirit of profound empathy.

Sargent was sixty-two years old when, during World War I, he gathered himself into a makeshift uniform and crossed the Channel to France with his sketching equipment. He was described as looking like a "sailor gone wrong" and one imagines how unsuited to the rigors of campaigning he was—a man who described himself as having never seen anything horrible outside his own studio. He had become personally involved in the war through accepting an assignment from the Imperial War Museum to paint a large documentary work with the general theme of American and English soldiers working together. Through the desolate days and nights spent in close proximity to the fighting, Sargent searched for a meaningful composition, but despaired of finding anything. Both the oppressing gloom of these days, and the high drama of the events that were being acted out, seem to be captured in the tentative sketches and in the oil studies Sargent executed in the hope of extracting a theme.

Watercolor continued to serve him well as a sketching medium, and when the crash of battle abated and life returned to a more normal condition, his old preoccupation with light returned. *Dugout* might have been drawn on the sunny floor of the *Val d'Aosta*,

but for the grim reminder of war in the objects caught in the skillful passage of his luminous washes of color. Nevertheless, in the most innocent looking of these scenes of war a mood of pathos lingers.

During that summer of 1918, the problem of the large documentary painting continued to press upon him. Then, by some chance, he came upon a field medical station on the Arras-Doullens road. He recalled the shock, the "harrowing sight . . . a field full of gassed and blindfolded men" and without hesitation began rapidly sketching all that he could cram into his notebook. Returning to England, he immediately began incorporating the sketches into the large composition that the War Museum had requested. The painting was completed by August, 1918, the work of feverish and inspired concentration. All of the recurring pictorial ideas that had appeared again and again in other forms are contained within this last great painting of Sargent's career—from *Luxembourg Gardens at Twilight* of 1879, to the *Frieze of the Prophets* of 1895. It is a final summation of his convictions about the art of painting. There is no sentimentality in *Gassed*; indeed, its very title is intended to convey something of the brutal facts that had so appalled Sargent in the torn fields of France. In fact, this frieze of soldiers silhouetted against the infinite spaces of a weary sky has the quality of great Greek tragedy.

By 1921, the final elements of the Boston Public Library were in place and the grand design made whole. Reviewers hailed the work as the Sistine Chapel of American Art. For Sargent, this intricate and carefully wrought composition must have seemed a crowning of his career.

He had not lost his brilliant, incisive way with a simple pencil drawing, in spite of platoons of eager sitters who pressed him for portraits in charcoal. And amid the feverish activity of his last visit to America in 1921, a flash of his old, trenchant style occasionally shot forth in these charcoal sketches.

By the next year, Sargent had begun working on yet another set of decorations, this time for the Memorial Library at Harvard University. Not only was this last set of decorations smaller in scope than its predecessors, but its theme of patriotic fervor and soldierly sacrifice almost totally lacked conviction. Once more the handsomely realized preparatory study for *Conflict Between Victory and Death* is superior to the final painting of the same subject. Similarly, its companion design, *Soldiers of the Nation Marching to War*, has no more feeling than the studies for it, it is only more finished. It is as if Sargent had expended all of his interest upon the studies, and these become the "original works," while the painted murals are only spiritless replicas.

Sargent died in London before he could see the final sections of

his Museum decorations in place. His critics, particularly those who had taken up the cudgel for the *avant garde*, renewed the vigor of their attack in the years following 1925. Their principal point in criticism of Sargent was that his art too faithfully mirrored the appearance of the world. By this time appearances no longer counted for much in art unless they were sustained by subjective qualities. Sargent was not a theorist; if anything, his faith was pinned to a system of rules and a sense of order that found nourishment within itself. However, his mind often grasped and admitted much more than his critics realized. He was not simply "a great eye," all technique and virtuoso dash, playing out to the end effortless and unsubstantial manipulations of magnificent paint. He was constant to the credo with which he had begun his career in the days of Carolus-Duran's studio—that "all that is not indispensable is useless." His technique was not an end in itself, but a means by which he could quickly arrive at succinct statements concerning the world that moved and lived around him. Sargent's eye saw the presence of the world more directly, and his mind resolved that presence into pictorial realism more trenchantly, than any other artist of his time.

The watercolor medium had been used in the 19th century as a serious means of expression by only a handful of artists. Generally, it was considered to be a sketching medium, employed more often by graduates of genteel "female seminaries." Turner, working in the early part of the century, used it with great distinction; Winslow Homer gave it importance in America.

Sargent's early watercolors reveal his difficulties with the technique, and aside from a scattering of examples between 1885 and 1900, he seems to have paid it little attention. His first sustained use of watercolor took place around 1905; these paintings show considerable care in execution, relying on underlying notations in pencil for perspective and general design. Very quickly, Sargent was applying a vigorous brush to paper with a *brio* that is unmatched. Watercolor seemed to release him from constraints about pictorial "manners"; since most of this output was not intended for exhibition, he may have had fewer reservations about "letting go" than was possible with the things he put before the public or a client. Many of his best watercolors became gifts to friends and to members of his family—often inscribed with a brief dedication. Sargent looked modestly upon these efforts, and was amused when a collector insisted upon getting a title for the work. When pressed, he usually responded with an intentional absurdity, such as "Blokes" for a group of figures, or "Vegetables" for a garden scene.

As Sargent's fame grew, so every available work became increasingly interesting to collectors and museums; the watercolors, which Sargent had formerly given away so casually, were now in demand. The market probably had as much to do with this as any factor. At a time when he was asking twelve thousand dollars for a full length portrait (1906), watercolors could be had through his dealers for no more than two hundred fifty dollars. In February, 1909, M. Knoedler & Company held an exhibition of Sargent watercolors in New York at their old address on Fifth Avenue at 34th Street. Sargent's old friend from Boston, the painter Edward Darley Boit, shared the galleries with him on this occasion. The critics' evaluation of Boit's watercolors can only be discovered by reading yellowed newspaper clippings. Sargent unwittingly eclipsed his old friend; Boit shared the fate of many of his contemporaries who were too close to Sargent's influence.

However, the eighty-six examples of Sargent's work on view at Knoedler's precipitated an extraordinary event. The then president of The Brooklyn Museum, A. Augustus Healy, had been extremely enthusiastic about Sargent since 1907, when Sargent had painted his portrait. Healy saw the exhibition and approached his Board of Directors, fired with a desire to acquire the entire group for the Museum. A price of twenty thousand dollars was agreed upon by the artist's dealer, and Healy set about raising the funds, contributing toward the purchase himself with a large donation. For reasons not known, the Museum elected to purchase only eighty of the watercolors, leaving three with Knoedler. Healy's wisdom was demonstrated with the precision that the economics of art can give when, in 1921, The Copley Society of Boston borrowed merely fifteen of the original eighty and insured them for more than the purchase price of the entire group.

Healy's dramatic sweep of the Knoedler exhibition apparently caused other museum officials to consider the Sargent watercolor phenomenon. In 1912, the Museum of Fine Arts, Boston, purchased an equally impressive forty-five. Three years later, The Metropolitan Museum bought eleven directly from Sargent, with funds provided by a bequest left to the museum by the newspaper publisher Joseph Pulitzer, whose portrait Sargent had also painted in 1905. The director of the Museum, Edward Robinson, another Sargent sitter, negotiated for the group of watercolors at the going price of two hundred fifty dollars each. Sargent wrote from London, thanking Robinson for prompting him to act on, ". . . your repeated suggestion that I should report something that strikes me worthy of the Museum." Following the interest that was aroused in Sargent's spectacular Florida watercolor series, the Worcester Art Museum snapped up eleven examples of these for its distinguished collection.

That same year, 1917, the Carnegie Institute in Pittsburgh mounted an important exhibition which compared a selection of

INTRODUCTION

twenty-four watercolors by Winslow Homer with eighteen by Sargent. Among the Sargent lenders were three prominent museums—Brooklyn, Fogg, and Worcester. The Carnegie exhibition was the high water mark of Sargent's cresting fame. In a sense, it was an indication of the extent to which Sargent had repaired his reputation as an artist. The watercolors are free of the taint of servitude to the demands of international society, and possess a powerful technique which cannot be faulted for superficiality— objections which Sargent's critics have always pointed to as the fatal flaws of his art, particularly in the case of his later portraits. Favorable comparisons with one of the great masters of the native school of American realist painting, Winslow Homer, also served to remove the distance between Sargent and his American audience, who had regarded him largely as an exponent of Old World values.

Without doubt, the passage of time has served to temper some of the harsh judgments once leveled at Sargent the portrait painter. Even Sargent's severest critics cannot deny the enormous appeal of his watercolors; there are few artists who have responded with greater visual excitement to the world of light and form. Sargent's watercolors obey the requirement of art in the most important way: they remain forever fresh, they endure.

Color Plates

Portraiture was the rock upon which Sargent built his career. In the decade of the 1890's, his position in this field was supreme. While the settings he employed for his subjects were often conventional, the attitudes in which he caught his sitters were subtly insightful, telling much about their character, which could be discerned in the angle at which a head was turned, or the tension in the figure or gesture, and not by facial expression alone. Before 1900, watercolor portraits were rare in Sargent's work, and they were usually tentative, in the manner of studies, with emphasis upon drawing and modeling rather than upon color.

The portrait of the unidentified man in this watercolor reveals much about Sargent's approach to portrait painting—the form of the head is built up through the accurate definition of planes which impart solidity. Here, he works toward that form by beginning— as he did in oil technique—with the middle tones. He then proceeds toward the darkest values, with the final tones applied very much in the manner of scumbling, as in the upper right background area. Characterization is achieved through the nearly sculptural quality of the head, which is allowed to glow in warm, transparent lights. Sargent has observed the difference in local color—the head appears tanned by the sun, while the hand, tenacious and equally strong, is reddened with labor. The man appears to be the Mediterranean type which appealed to Sargent during his search for authentic models for his Boston Library compositions.

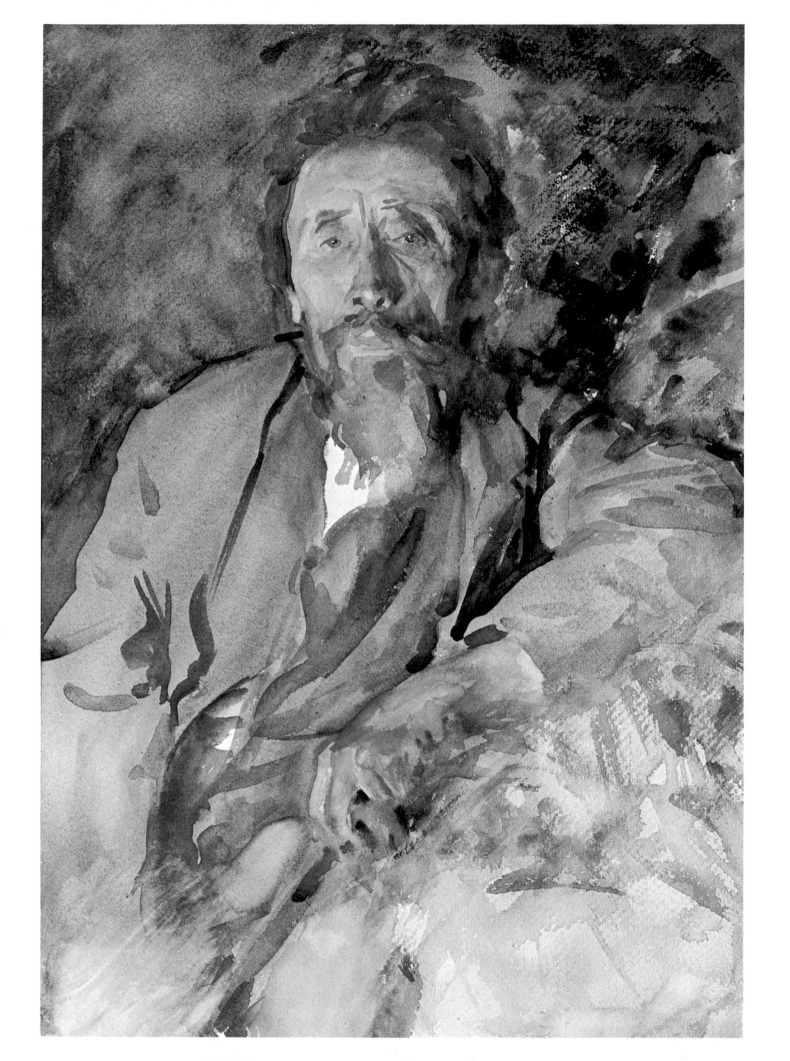

Following a brief, but highly active visit to the United States in the winter of 1903, Sargent returned to Europe in May of that year. The designs for the Christian section of his Library decorations were only half complete, lacking the parts that eventually centered on the figure of the Virgin. The fact that Sargent sailed directly to Gibraltar, and then spent some time traveling in Spain, may indicate an international detour specifically to provide some ideas for the next portion of his mural work. When it was finished, his composition for *Our Lady of Sorrows*, showing the Virgin crowned and with swords thrust into her heart, betrayed the influence of traditional Spanish religious art. On the basis of the handling of the medium in the *Spanish Fountain*, with its somewhat tight drawing and somewhat tentative applications of color, it seems plausible to assume that this work probably dates from Sargent's 1903 travels in Spain.

Architectural details served Sargent as arrangements of still life objects might serve another artist. Throughout his career, Sargent seems to have combined architectural fragments into larger compositions, but, at the same time, these fragments were enjoyable in themselves as exercises of his art. Often in Sargent's studies there is the suggestion of the inveterate note-taker at work. However, in *Spanish Fountain* another interest is apparent, in addition to his usual ones. Early in his career, Sargent showed a peculiar fascination with the effects of indirect and reflected light. Impressionism interested him mainly to the extent that it opened up new ranges of color in which light could be approximated in painting. Sargent never thought of Impressionism as a method; color was not to be blended in the beholder's eye, but achieved by the artist as directly as possible in the work itself.

Spanish Fountain reveals a nearly scientific observation of reflected light. While the entire tonal effect is balanced and somewhat unified in intensity, Sargent has carefully noted and recorded at least three distinct sources of reflected light—all existing within the confines of the central subject. The basin of the fountain is given a warm violet hue, reflecting the light from below; the figures of the *putti* on the column catch and reflect light from sources at the side; and the pool's rippled surface scatters the colder reflections of the overcast sky.

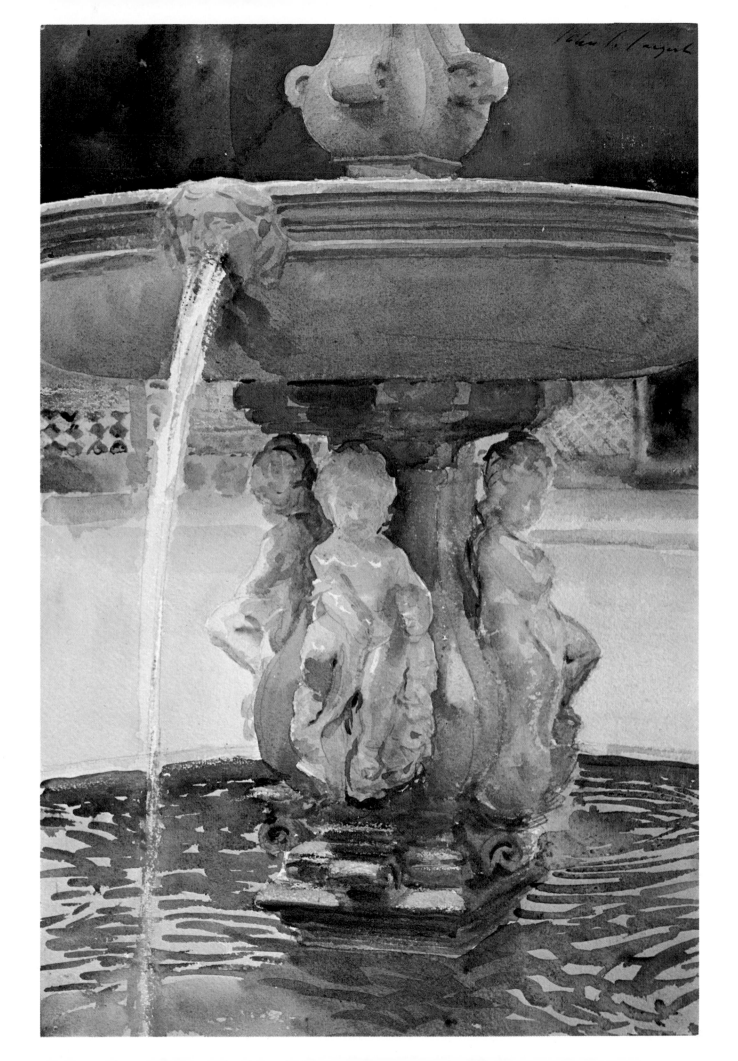

Plate 3.

SANTA MARIA DELLA SALUTE, 1904
18⅛" x 23" (46.0 x 58.4 cm)
The Brooklyn Museum
Purchase, 1909

Venice became part of Sargent's life as early as the summer of 1880, when he took a small studio in the Palazzo Rezzonico. His cousin, Ralph Curtis, lived a short distance away on the Grand Canal in a great ancient house which had been recently acquired by his parents, the Daniel Sargent Curtises. This imposing 15th-century mansion, the Palazzo Barbaro, offered hospitality to many visitors over the years, including Isabella Stewart Gardner, for whom the *palazzo* served as the inspiration for the creation of her own Fenway Court, in Boston. From the windows of the Barbaro, the great dome and angled facade of the *Salute* could be observed, silhouetted against the eastern sky.

Sargent painted this church many times, usually concentrating upon the handsomely detailed Baroque decoration of its portal. Here, the view taken looks southwest, so that only one of the flanking elements of the portico is visible. In the distance, at the right, the apse of the Church of San Gregorio is barely, yet discernibly, indicated. The general impression of this watercolor is one of accuracy, especially in the details of the architecture; yet, upon close inspection, everything is rendered with a fluency approaching Im-

pressionism. In the foreground Sargent has dashed in a passage indicating the shapes of service barges on the Grand Canal. The boats are drawn convincingly in the simplest terms, and by comparison the architecture takes on a degree of study. Sargent often employed this means to concentrate attention upon specific focal points. The effect is like that of a photograph in which depth of field is distorted to create emphasis. In this picture, as in many others, Sargent found the study of architecture and its decorative elements profitable when he considered the problems he faced as a mural artist.

The sacristy and picture gallery of the *Salute* contain some notable examples of Renaissance paintings, including *Marriage at Cana*, by Tintoretto. In fact, at this time Sargent copied Tintoretto's *St. Jerome, St. Roch, and St. Sebastian*. There is an unmistakable similarity in the attitudes of the three saints to those in Sargent's own *Frieze of the Prophets*. While, undeniably, many of Sargent's watercolors, as well as paintings executed on holidays in Venice, were products of a restless urge to paint, many were inspired by his search for ideas for his Boston decorations.

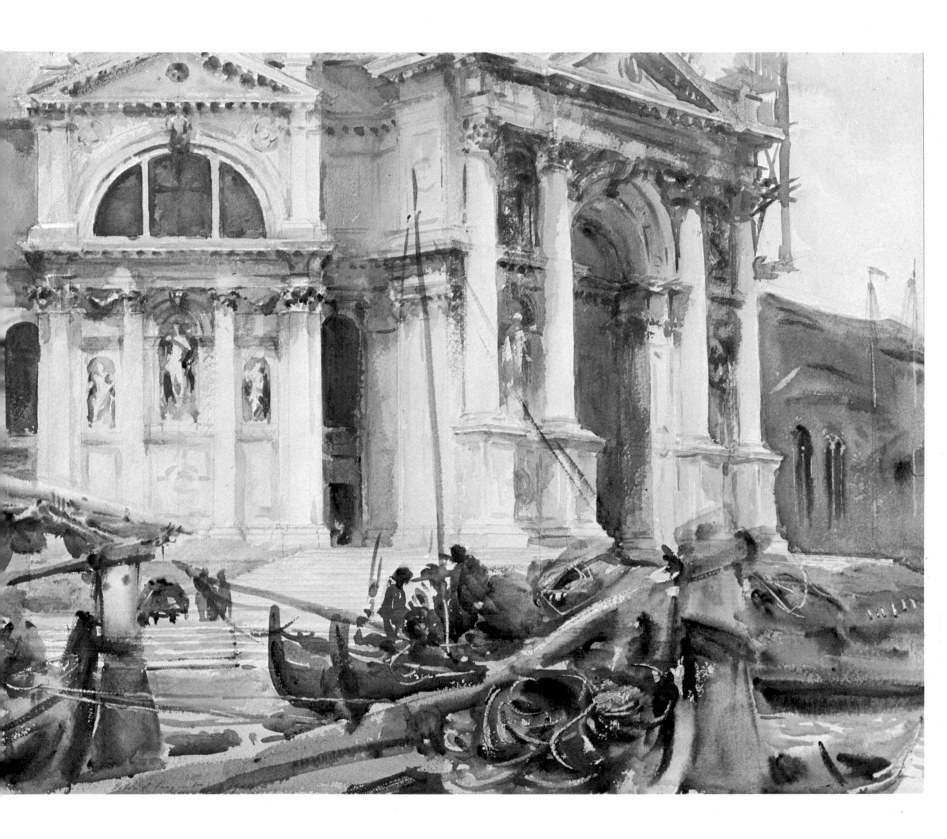

Plate 4.
TIEPOLO CEILING, MILAN, ca. 1904
14" x 10" (35.5 x 25.4 cm)
The Metropolitan Museum of Art
Gift of Mrs. Francis Ormond, 1950

In January, 1903, Sargent returned to the United States to supervise the installation of the second set of decorations designed for the south end of his hall at the Boston Public Library. The new addition was entitled *The Dogma of the Redemption*. It was intended to balance the decoration for the north end, of which the subject was *Paganism and The Old Testament*. Eight years separated the completion of these two elements of the large hall. However, eighty-four feet of ceiling and wall space had to be filled with connecting designs before the two ends were truly related in a unified composition.

At this time, Sargent increasingly turned his attentions to the problems of large-scale architectural decoration. On a trip through northern Italy, sometime during the middle of 1904, Sargent made a careful inspection of Tiepolo's ceiling decorations in the Palazzo Clerici, Milan. The Tiepolo decorations were commissioned in 1740, by the Marchese Giorgio Antonio Clerici, Marshal of Maria Theresa of Austria. They represent the last and greatest production in Milan by the Venetian painter, Giovanni Battista Tiepolo (1696-1770). The Palazzo was acquired by the Milanese government in the 19th century, and the long hall of the fresco decorations was frequently the scene of splendid receptions. Sargent found it to be proportioned nearly in the same scale as the one Charles McKim had designed for the Boston Public Library. Moreover, the plan of the Tiepolo work is episodic, with the arrangement of its figure groups leading the spectator around the room. Clearly, Sargent regarded this as an opportunity to learn from one of the great mural artists of all time.

Tiepolo gave the frescoes an encyclopedic title: *The Course of the Sun's Chariot Through the Skies Inhabited by the Olympian Gods and Surrounded by the Creatures of the Earth and the Animals Symbolizing the Continents*. That so grandiose a scheme could be unified must have appealed to Sargent, encouraging him toward the completion of his equally sprawling one. In Sargent's watercolor, the spectator is shown the central portion of Tiepolo's composition, and a part of the mirrored west wall of the gallery. The winged figure of "Time" at the extreme left is part of a section depicting *The Ravishment of Venus*, while to the right, on the cornice, is a group representing "Europe." Above these is the focal point of the entire composition, *Hermes and the Sun's Chariot*. Paolo Ancona, in his study of the frescoes, observes the special character of this work: ". . . the artist had altogether abandoned Piazzetta and Caravaggio . . . and had, instead, sought inspiration in Veronese's experiences and was trying to give new life and splendor to the use of pure contrasting color and value."

Sargent's decorations in Boston are not frescoes, but paintings in oil on canvas, later applied to their architectural supports. He had discovered one problem inherent in this project: that colors tend to darken when placed high above the spectator. This optical darkening of color was related to the architecture. Perhaps this was another reason for Sargent's study of the Clerici frescoes. Tiepolo had succeeded, throughout this work, in maintaining a high key palette, but the bright colors are controlled; they do not disintegrate the total composition. Sargent later applied this lesson to his own work, and the difference between the mural designs painted before 1904, and those that came afterward, is probably due, in part, to his study of Tiepolo.

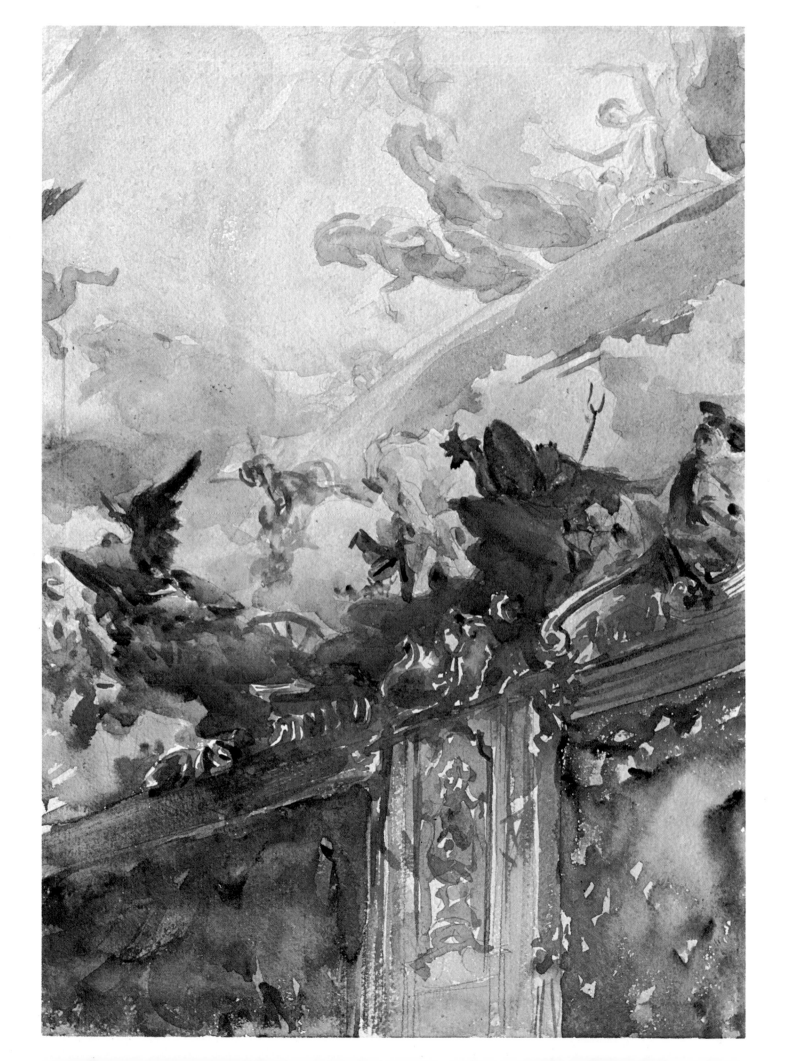

Plate 5.
VENETIAN DOORWAY, after 1900
21½" x 14⅝" x (54.0 x 37.1 cm)
The Metropolitan Museum of Art
Gift of Mrs. Francis Ormond, 1950

While the pictorial qualities inherent in landscape painting appealed to Sargent, the convention of using the reality of the visual world as a reference did not always dominate his pictures. There is the unmistakable suggestion of Whistler's influence in certain abstract "arrangements" that Sargent began to employ early in his career. Both were in Venice in 1880, and it may have been that they met at this time. Whistler was there to do a set of etchings for the Fine Art Society of London, and may have met Sargent through another expatriate American, Daniel Sargent Curtis, owner of the Palazo Barbaro. However, much has been said about the nature of their friendship; it has been popular to attribute to Whistler certain unkind remarks about Sargent's art. That Sargent regarded Whistler highly cannot be denied; in 1894, he worked to get Whistler a commission to decorate a portion of the main stairway at the Boston Public Library, where his own project was in progress. As early as 1882, Sargent had begun to incorporate compositional devices in his paintings that strongly suggest Whistler's influence.

Curiously, the principal examples of paintings presumably influenced by Whistler were executed in Venice. Taking street scenes as subjects for many of his Venice paintings (as well as interiors, on occasion) Sargent created divisions in their compositions which tend to make flat patterns of the architectural incidentals against which figures are placed. This watercolor of a single, anonymous doorway can be related to the artist's interest in achieving purely abstract pictorial harmonies. On the other hand, dozens of his other Venetian watercolors, made with the same selectivity of detail, show Sargent's interest in architecture for its own sake.

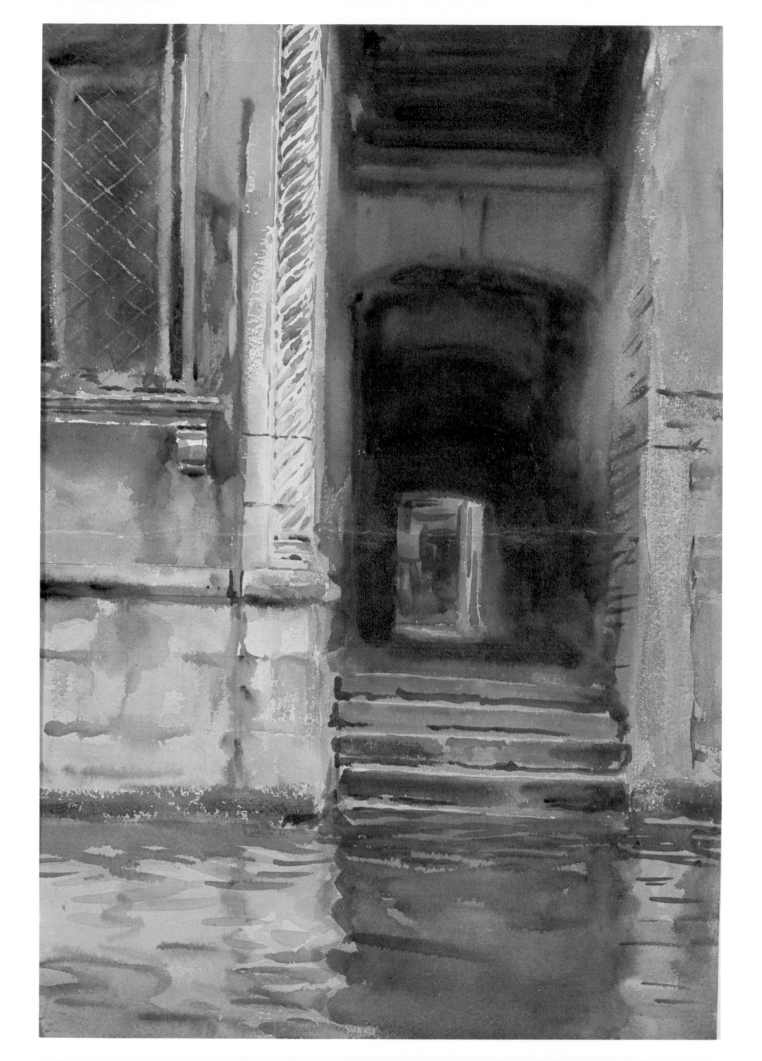

Plate 6.
MELON BOATS, ca. 1905
13¹³⁄₁₆″ x 19¹¹⁄₁₆″ (35.1 x 50.3 cm)
The Brooklyn Museum
Purchase, 1909

In December, 1905, Sargent removed himself from the winter gloom of London for the warmth of Palestine. His announced intention was to continue the search for authentic ethnic types whose portraits, presumably, would find immortality somewhere in his plans for the Boston Library decorations. He had recently completed his largest, and in some ways most cloying, portrait commission—the Duke and Duchess of Marlborough and their children. He had grown so weary of the task that he set about to parody the style of the grand manner portrait, and his own style too, by posing his friend Ena Wertheimer in the Duke's ceremonial robes of state and then painting her in a pose of nearly wanton abandon.

The trip to the Holy Lands was a solitary pilgrimage, unlike any of his others. It seems probable that Sargent really had no fixed idea of what the trip should accomplish, other than getting him free of London's clamor for more portraits.

Thus, with a large supply of paper and canvas, he landed at Haifa. Few of his works from this trip are identified with place names; however, *Melon Boats,* his own title for this watercolor, can be ascribed with some certainty to Haifa. The boat represented is a *dhow,* an Arab vessel whose lanteen sail boom may be seen extending upward and out of the composition at the upper left. Amidships, in the broad, open hold, the cargo glows in the noonday sun. The *dhow* was common in this area; it was used for carrying coastal freight along the eastern shores of the Mediterranean.

This is a work built upon contrasts: sunlight and shadow; air and substance. Sargent could make bedsheets drying on a line into a compelling image, and so, in *Melon Boats,* Sargent became excited about the play of back lighting on a translucent sail. The challenge is formidable. However, Sargent succeeded in achieving a palpable representation of this elusive substance: the wrinkles in the sail become a pale blue gray; the fullness of the sail in the sun, a pale yellow, graduating to ochre and finally to blue as the shape of the sail's curve is described. This is a feat which looks deceptively simple, yet it calls for the most analytical sort of coordination between eye and hand. Against the airy, insubstantial clouds of sail, Sargent contrasted the solid forms of the boats at mooring. The color is opulent, powerful, and velvety. In the distance, the cloudless sky over Haifa is rendered with a simple wash of ultramarine, but because the complex principal subject dominates the painting, the sky takes on an atmospheric transparency giving the viewer an uncanny sense of vast distances beyond.

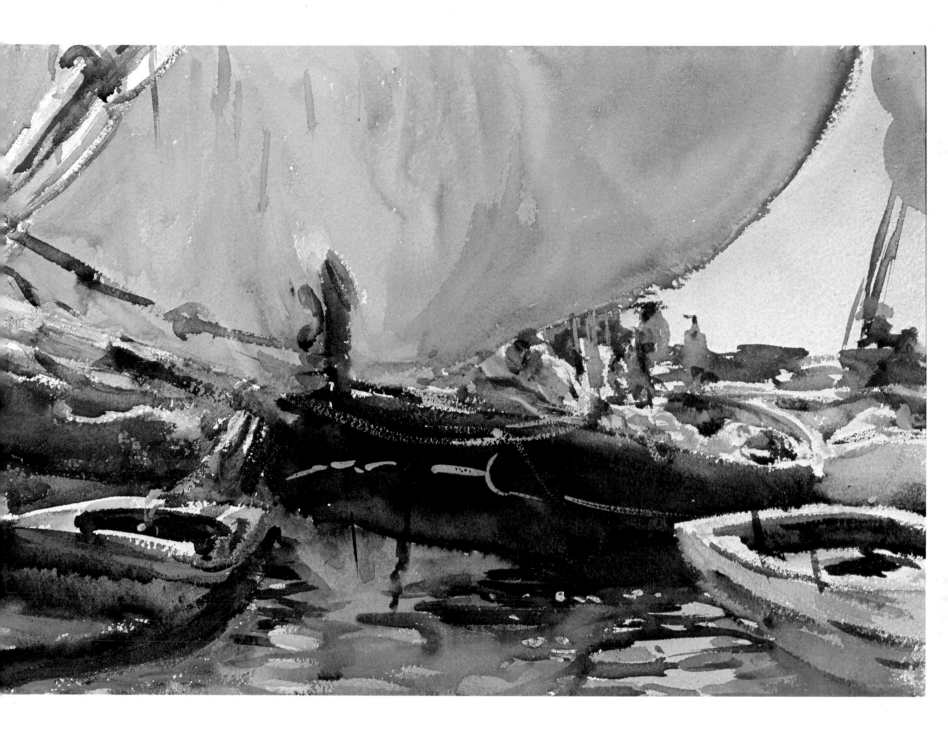

Plate 7.
MENDING A SAIL, 1905
11" x 13¹³⁄₁₆" (27.9 x 35.1 cm)
The Brooklyn Museum
Purchase, 1909

Sargent hoped that his 1905 trip to the Holy Lands would add "new fuel for his decorative work," as his friend Evan Charteris observed. There is a suggestion in the quotation that Sargent was concerned about maintaining his creative momentum with regard to a project that was now in its fifteenth year. Considering the evidence of this expedition, Sargent seems to have found little to incorporate into notes for future reference. Rather, the many sketches attest to his interest in studying the effects of intense light upon different colors.

Mending a Sail bears little upon the appearance of the Arab fishermen; it is a perfect example of what Sargent himself referred to as a "snapshot" picture. By adjusting his range of color to a consistent high key, Sargent has managed to convey the effect of light with an utmost economy of means. The arrangement of the figures, also, seems perfectly natural, but it deliberately leads the eye into the composition. Both in terms of color and composition, this watercolor is at once spontaneous and precisely controlled. Sargent's ability to make a convincing scene out of such seemingly casual notations, is nowhere more apparent than in the indications of the most distant figures, set down as mere silhouettes of color, drawn swiftly with a loaded brush.

While Sargent never made his itinerary known, and the letters from this trip are few, the watercolors give some indication of the course of his wanderings. From Haifa it appears that he may have gone directly to the ancient city of Tiberius, on the shores of the sea of Galilee. The Arab fishermen certainly would have been an obvious source of information for his designs for the Christian iconography of the Boston Library composition. In a letter to his friend Lady Lewis he alluded to one of the miracles of Christ, saying, "Some new material I have secured but it is different from what I had in view and not abundant—no *miraculous draught*, but I shall still fish here for awhile. . . ." Ironically, the careful studies he made of Roman ruins at Tiberius are empty of real interest by comparison with such brilliant sketches as *Mending a Sail*.

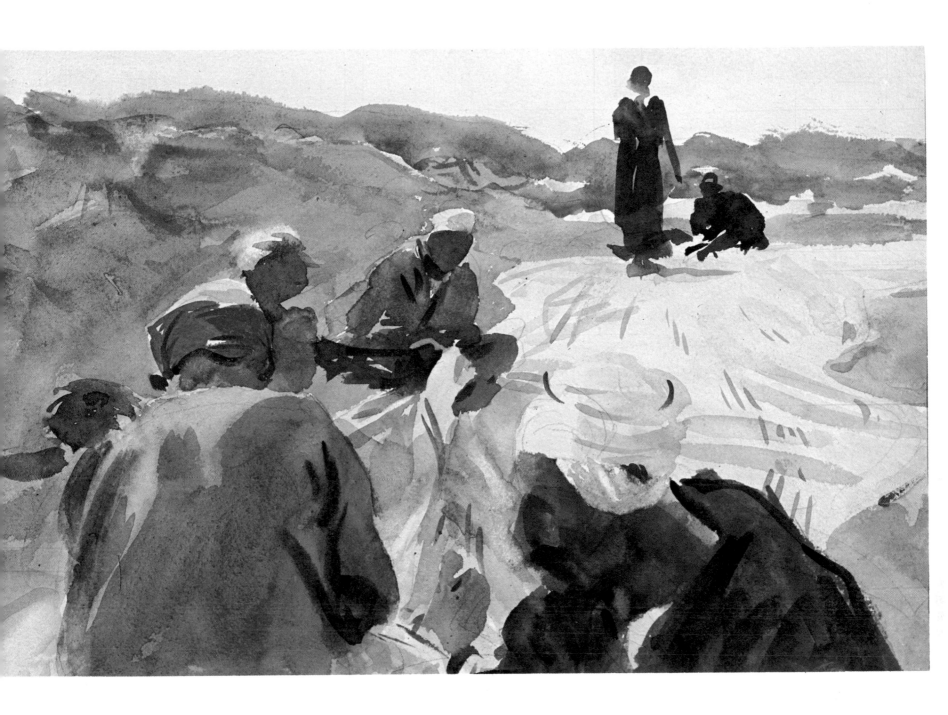

Plate 8.
BEDOUIN MOTHER, 1905
17⅞" x 12" (45.4 x 30.5 cm)
The Brooklyn Museum
Purchase, 1909

Finding so little to occupy his time in the old towns of Palestine, Sargent spent the better part of his trip searching out new landscape subjects to paint. Occasionally, he stopped his rush of work long enough to inscribe a watercolor or an oil study; places such as the hills of Galilee, the plains of Esdraelon, the Dead Sea, and the valley of the Mar Seba can be identified in the mass of sketches. At some point between Tiberius and Jerusalem, Sargent came across a band of nomadic goatherds living in the desert. At last, he had found authentic subjects in the Bedouin tribesmen whose way of life had remained unchanged since the time of Christ. Most of Sargent's work in the Bedouin camp depicts life in the primitive tents and family gatherings around the cooking fires; occasionally, he ventured out with the goatherds and painted the animals grazing among the sere shrubs and rocks. The idea of generations being born and dying completely within the limits of this type of existence appealed to Sargent's curiosity and admiration.

Bedouin Mother is a small picture of monumental conception. The heads of the mother and child are lost in the dramatic shadow of the tent entrance, while the figure of the mother looms massively powerful in the full desert light. The anonymous character of this work becomes all the more symbolic because of the mother's strong protective arms embracing the figure of the child.

This theme found its resolution in Sargent's Boston Library decorations in a panel entitled *Ancilla Domini*, showing the Virgin in precisely the same attitude of protection toward the infant Jesus. Although this panel was not installed in the Library until 1916, the similarities between the watercolor and the mural decoration are so striking in conception and thematic treatment that *Bedouin Mother* must have been the actual inspiration for the later work.

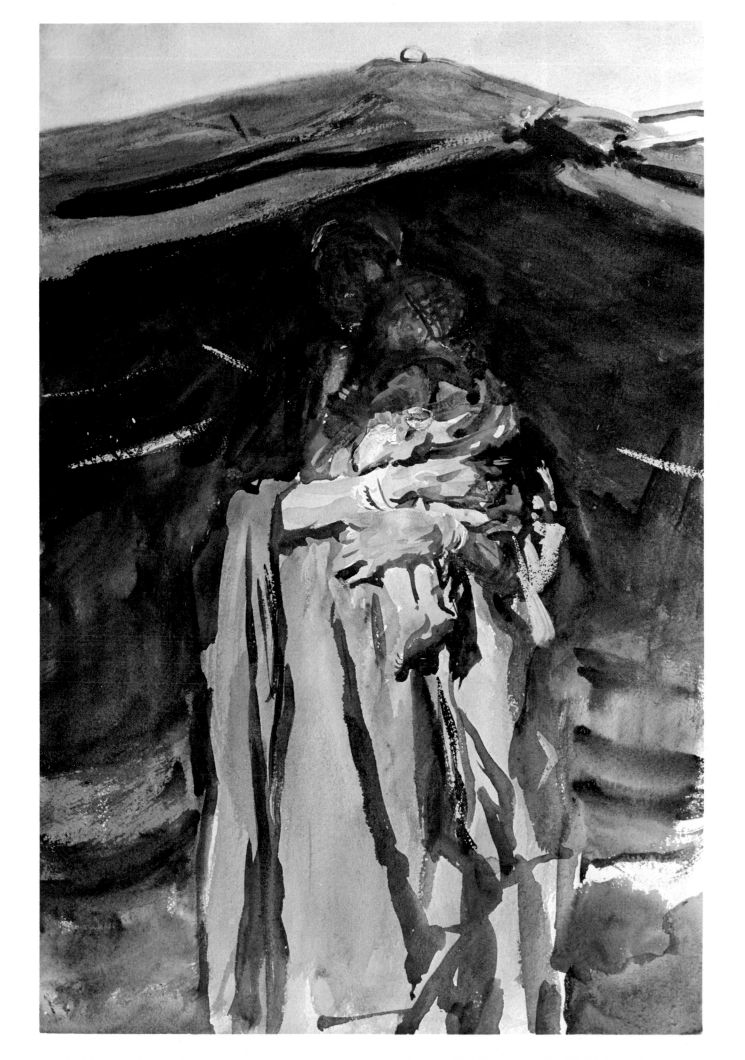

The many watercolors Sargent painted of these desert nomads focus upon the close community of the tribe, symbolized by the protective spread of the tents in which the nomads sustained life against the rigors of the hostile desert. The figures of the Bedouins themselves presented Sargent with an element of mystery, to be fathomed in his observation. In *Black Tent*, Sargent seems to be working toward capturing a feeling of that mystery: the figures are shrouded in the voluminous folds of their burnooses and set against the richly glowing depths of the tent. The whole performance is one of masterly handling of the technique of broad washes, ranging all the way to opaque highlights. The effect of drifting blue smoke in the middle distance is accomplished with incredible ease, yet the description is exact. For all of the generalities in the forms described, the work attains a feeling for reality and life.

One of the compositions Sargent invented for the Boston Library decorations was to convey the idea of the People of Israel being given the Law by Jehovah. This composition became one of the six lunettes installed in 1916, along with that portion dedicated to the story of the Virgin and Christ. In the lunette of the Law, Sargent chose to portray a symbolic figure representing Israel. The figure is covered with the mantle of the Almighty, and is depicted studying the law that had been laid down for the guidance of the chosen people. The symbolism of the tent mantle is too appropriate for Sargent not to have used it when the time came for the creation of the Law lunette, and its origins may be seen in these 1905-6 watercolor studies of primitive life in the Palestinian desert.

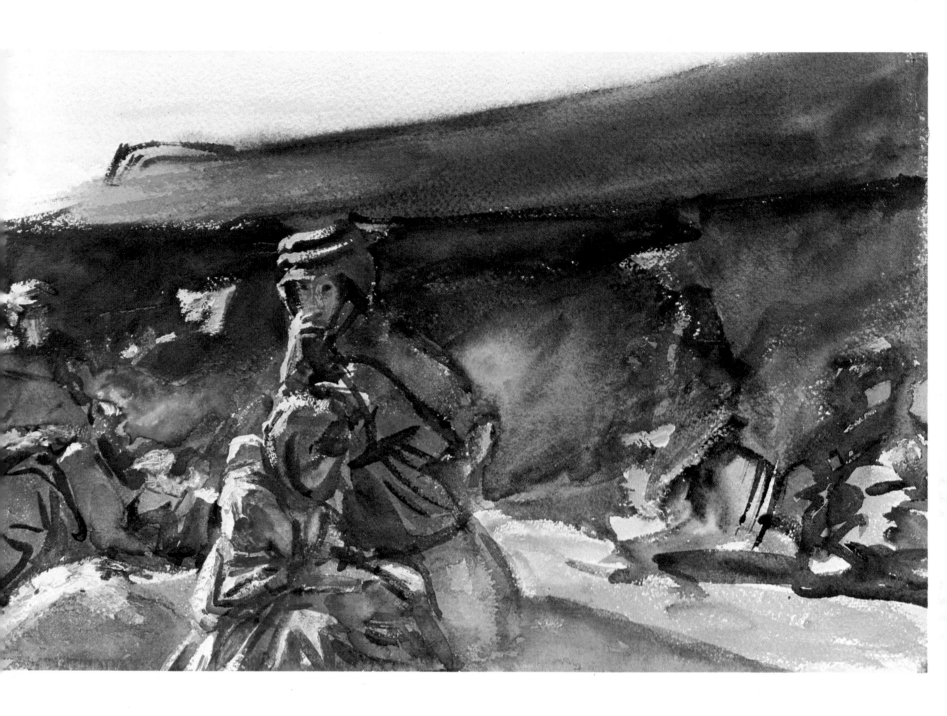

Plate 10.
ARAB STABLE, 1905-6
10⅞" x 14⅜" (25.1 x 36.5 cm)
The Brooklyn Museum
Purchase, 1909

Standing in the doorway of this unknown stable, Sargent created one of his most opulent watercolors. With the light at his back, throwing a flat illumination upon the burnished bodies of the horses, the challenge lay in making the forms round and the space three dimensional. This Sargent accomplished with an ease and a fluidity of application that never fails to arouse a feeling of admiration in those who enjoy the luminous delights of great watercolor painting. The impression of pearly light, and the description of the lustrous coats of the horses, combine with masterly drawing and persuade the spectator of the palpable reality of the painted scene.

Sargent made another watercolor of horses in Jerusalem, which he sold to Isabella Stewart Gardner of Boston. In a letter to her, he described his feelings about the magnificent Arab horses he so admired: ". . . they ought to have had blue ribands plaited into their tails and manes, like Herod's horses in Flaubert's beautiful Herodiade." Shortly afterwards Sargent left Palestine; he was discontented with the sum of his efforts which he saw as, "lots of impossible sketches and perhaps useless studies." However, this trip had not been a waste of time. Aside from the obvious excellence of even the quickest of his "snapshot" sketches, his wanderings in the desert had given him germinal ideas which would find fruition many years later.

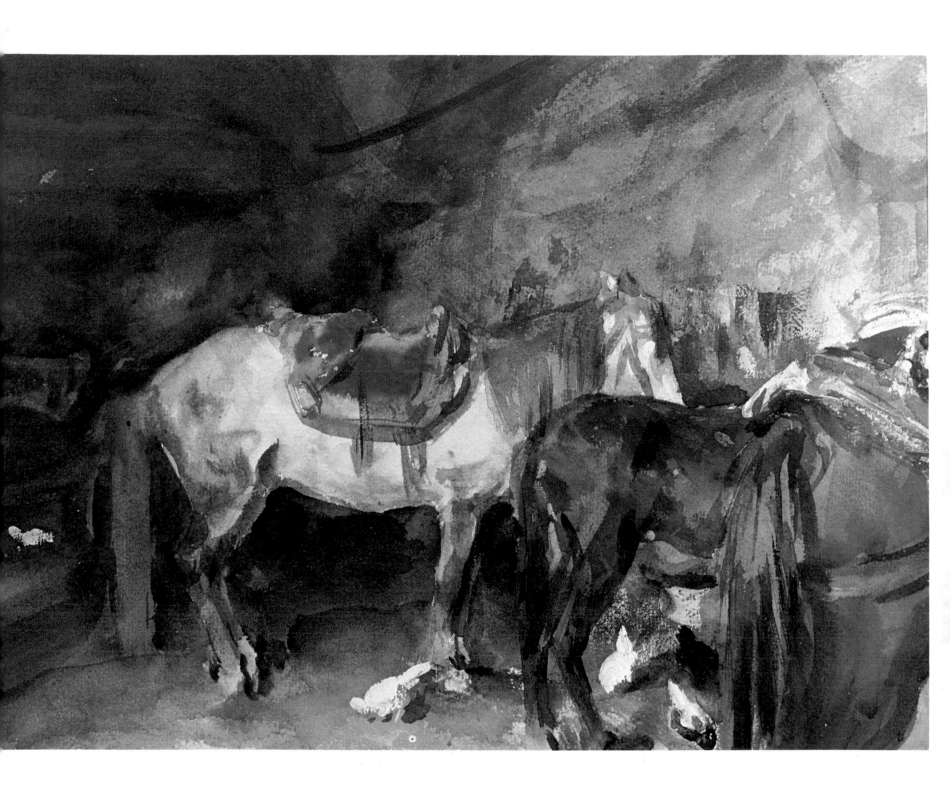

Sargent once exclaimed to some friends who were urging him to paint a great view they happened to admire, "I can't paint *views*. I can paint objects; I can't paint *views*."

One of Sargent's most appealing virtues in watercolor is the unexpected subjects of his interest—an interest which saw extraordinary potentials in the simplest aspects of nature. Sargent's precept seemed to be that without an understanding of the details, one could not possibly go on to an understanding of the whole. The evidence of Sargent's total *oeuvre* argues for his concern with the relationships of small details to their enveloping atmosphere and environment. In his view of the world no object is really an isolated phenomenon. There is a logical consistency in his work, be it on the level of correctly adjusted values in his painting, or in the matter of the relationships of the ideas which his art sought to express in plastic terms.

Gourds is an example of Sargent's astonishingly acute ability to synthesize visual experience with the discipline of art. The picture is at once a "snapshot," as Sargent termed such spontaneous efforts, (he early developed the habit of trying to reproduce exactly what his eye took in) and a carefully balanced composition. The challenge of the chaotic tangle of vegetation must have excited him, it is essentially an "unpainterly" subject. Yet the delightful foil it presents for the smooth, simple geometry of the gourds is everywhere realized.

The miracle of this watercolor is that the drawing and painting merge in a single act of creation. The seemingly confused planes of the leaves take their places within the nearly tangible space of the picture. In the decade of the 1880's, when Sargent gave himself over, temporarily, to the pleasures of Impressionism, he discovered a new approach to *plein air* painting. Instead of working with the effects of full sunshine, he set about painting the colors of nature in reflected light or shade. His palette was noticeably changed by this experiment, giving much more emphasis to cool colors. The gourds, hanging in the shade of a dense arbor of leaves, suggest a cool color composition with lavender and viridian predominating.

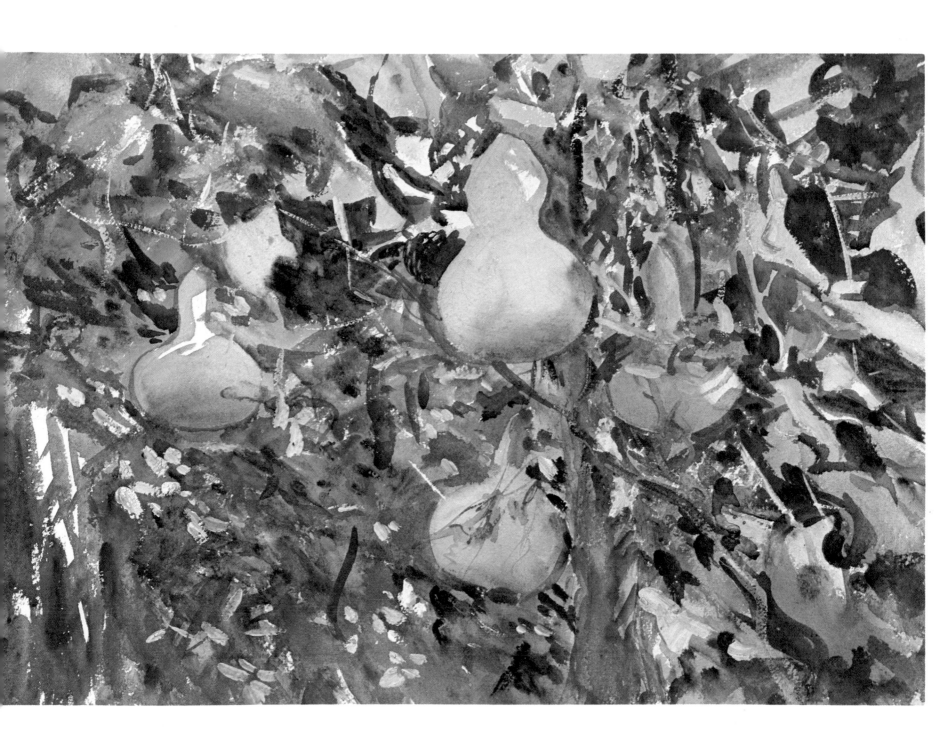

Plate 12.
IN SWITZERLAND, 1908
9⁷⁄₁₆″ x 12⅝″ (24.0 x 32.0 cm)
The Brooklyn Museum
Purchase, 1909

By 1908, Sargent had reduced his portrait commissions as much as possible, and that year was really the last he can be said to have seriously given his attention to this aspect of his career. He had been heard to exclaim more than a few times, with unaccustomed fervor, that the idea of painting the human face gave him a great sense of revulsion. In 1906, he wrote to his friend Lady Lewis, "I have now got a bombproof shelter into which I retire when I sniff the coming portrait or its trajectory." The perfect shelter was, of course, the Continent, especially those remote mountain villages in the Italian and Swiss alps.

In the summer of 1908, Sargent escaped to the Mediterranean, and thence to the Val d'Aosta in the northwest corner of Italy. In the company of his sister Violet and his old friends, Sargent could relax and enjoy life. He was frequently joined by a group of congenial souls whose companionship he had enjoyed for twenty years, ever since the summer spent at Broadway. Especially with the Harrison clan, he was able to share an interest in music. The evidence of several watercolor sketches and paintings, made during the summer of 1908, reveals that he was joined in the Swiss Alps by Alma and Lawrence Harrison, and Leonard Harrison. (Alma Strettel Harrison and Sargent once planned a book of Spanish songs, to be illustrated by him.) Together in Switzerland, they ex-

plored the mountains. Following a strenuous climb, while everyone else dozed in the mid-afternoon, Sargent would sometimes paint his friends reclining in poses of total indolence on some hillside in the shade of trees and parasols. These attitudes were utterly different from the formal treatments expected of him in the commissioned portraits, and the change of pace suited Sargent perfectly. In the event of rain Sargent continued inside, never permitting a moment to pass without some painted comment on this life of relaxation he so prized.

One of his most ingratiating "portraits," *In Switzerland*, was made in a bedroom of a simple inn (perhaps one near Breil, in the Glarner Alps, some twenty miles north of San Bernardino). Here he catches Leonard Harrison enjoying a nap, still in his climbing boots, sprawled out on an Empire bed. The plain plaster wall gave Sargent a chance to play with the subtle variations of the white of the wall and contrast it with the billows of the bedclothes. Sargent's interest was excited by the possibilities this offered. The composition, nearly monochromatic in color, shows how much Sargent could make of the most modest palette, with the minimum of drawing. The supine, foreshortened figure of Harrison, with his hand thrown casually over the pillow, is indicative of Sargent's mastery of descriptive line.

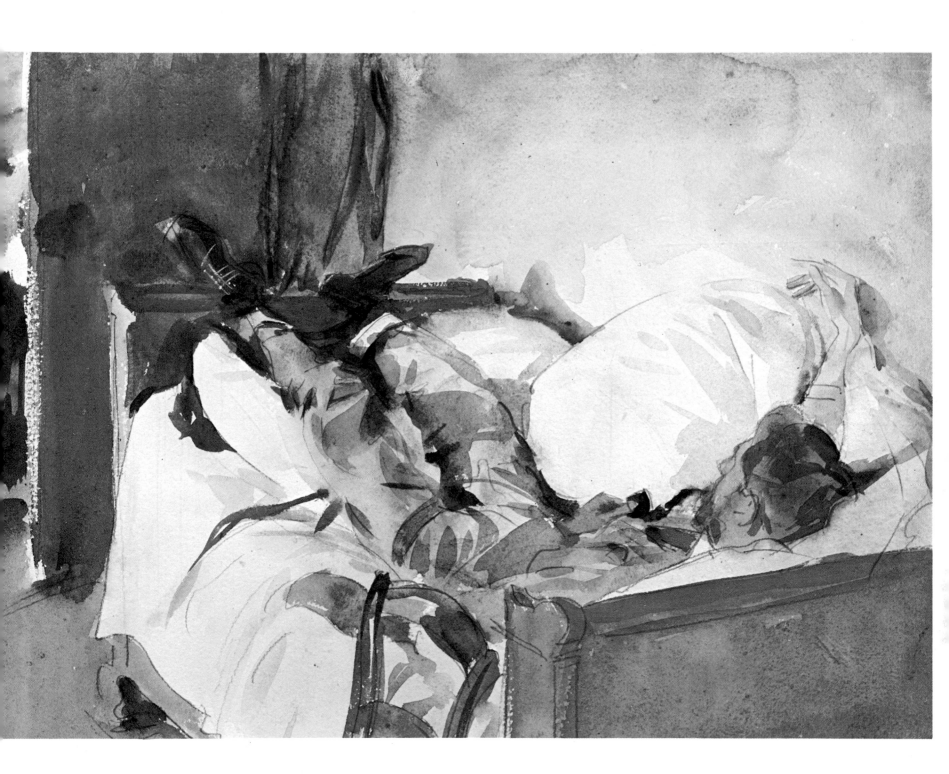

Plate 13.
IN A HAYLOFT, ca. 1904-7
15½" x 11¹³⁄₁₆" (39.4 x 35.0 cm)
The Brooklyn Museum
Purchase, 1909

Making use of every possible opportunity to seize a subject, Sargent kept at work while others might have found the same situation less satisfactory. Companions on painting trips were, themselves, the subject of sketches. The hayloft watercolor was made during a brief storm near Purtud, at the head of the Val d'Aosta. The two companions were fellow artists: Jean-Francois Raffaelli, shown here on the left, and Carlo Pollonera. Raffaelli served as the model in at least two other of Sargent's pictures: *Artist in his Studio* (Museum of Fine Arts, Boston) and *Reconnoitering* (Modern Gallery, Pitti Palace, Florence). Pollonera was with Sargent during several summers at Purtud.

The extremely broad handling of the sketch indicates the momentary nature of the occasion, almost as if Sargent were forced to achieve an instantaneous impression before the situation was lost. The silvery quality of the light striking the forms of his friends was caused by the diffused illumination of the cloud laden skies outside the barn. Sargent had been brought up in the school of the *portrait d'apparat*, and portraits were best for him when they reflected the natural attitudes and surroundings of the person.

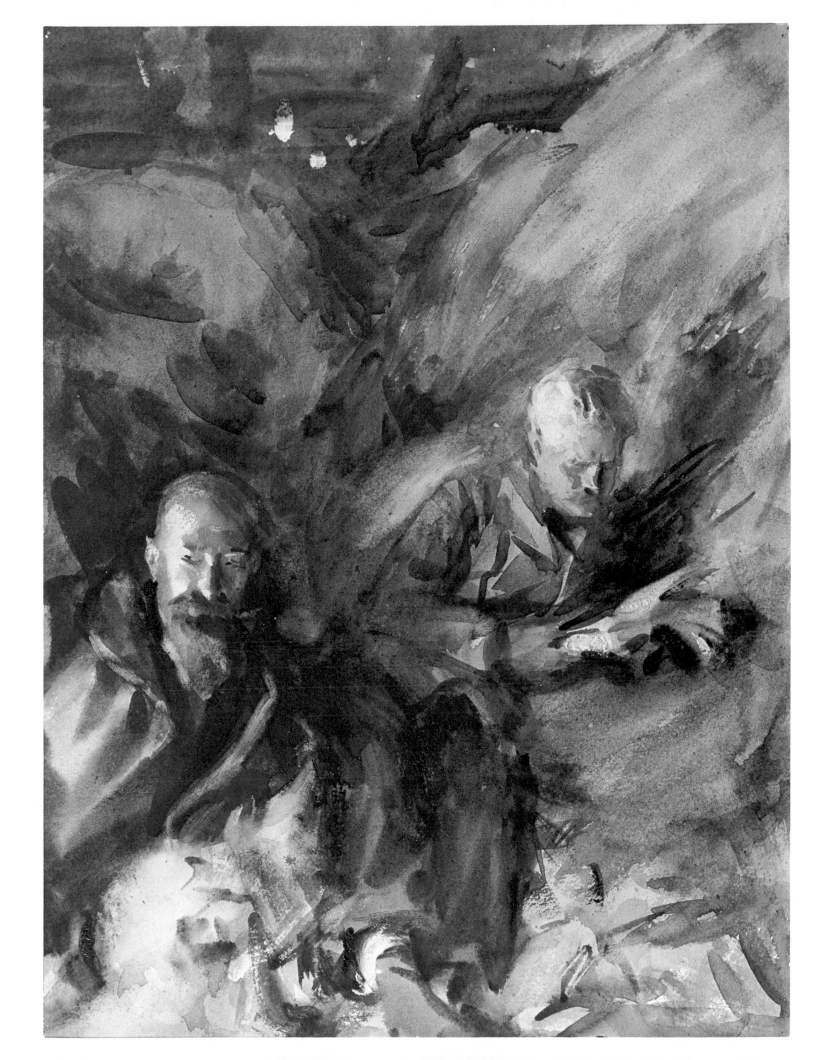

Plate 14.
IN THE SIMPLON PASS, ca. 1910
14⅛" x 20⅝" (35.9 x 52.3 cm)
The Brooklyn Museum
Gift of the Roebling Society of The Brooklyn Museum, 1968

Sargent's sister, Violet Ormond, and his nieces, Rose Marie and Reine Ormond, were frequently the subjects of watercolors and paintings made during the artist's periodic summer vacation trips to the Continent. In the sun drenched mountains of Switzerland, Sargent was particularly fond of painting these ladies resting under their parasols, dressed in summer white.

While ordinarily this kind of pose would seem to suggest the idea of the "keepsake," Sargent was primarily interested in the range of colors that could be found in white as it caught direct sunlight, and as it reflected the surrounding local colors in shadow. The clear air of high places, such as the Simplon, offered ideal conditions in which to observe this interesting phenomenon. These pictures were never portraits; moreover, faces, when treated at all, were given a general characterization. The results of this point of view often had a curiously abstract quality. *In the Simplon Pass*, takes great liberties with the treatment of the figure, suggesting rather than describing. The face of the person represented has no features, since the lady is wearing a veil, and she holds an invisible parasol handle.

However, the artist convinces us that the figure exists in space, in front of the landscape. The sharp edge of the gray-white sleeve against the warm green of the distant grass exactly establishes not only color, but spatial relationships. Sargent seems to have created a picture in which the beholder's eye is made to focus beyond the figure, much as a camera would when set for infinity rather than for close range. In so doing, he deliberately chose to reverse the normal order in a composition dominated by a foreground figure.

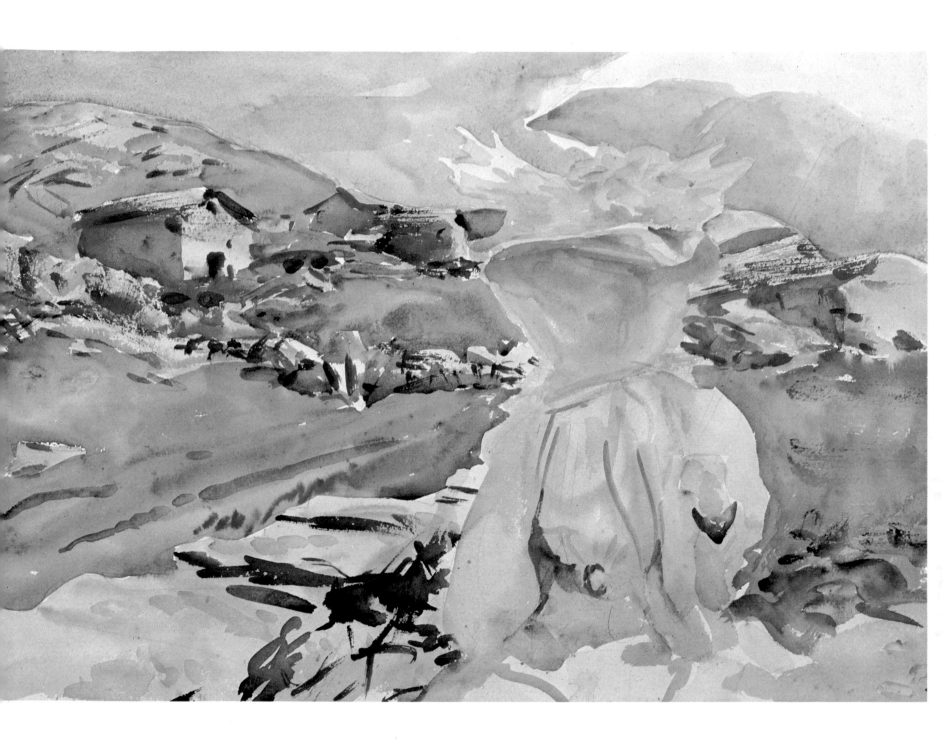

Sargent once described himself as a man who "has not seen any-
thing horrible outside my own studio." A peculiar air of detach-
ment encompassed his life, as commitment to causes often directs
the lives of other men. It might be observed of such a man that he
knows no fear or terror; he is instinctively drawn toward that
which excites his curiosity, without regard for his own safety.

Sargent's proximity to the fire, which he describes in this water-
color, is evident in the sparks, which he notes at the center of the
picture, trailing smoke on the updraft current of air. There is an
uncanny evocation of the smell and the crackle of fire in these deft
strokes of the brush; the eye almost moves with the slow upward
drift of the smoke and the occasional flying spark, as the fire eats
through the upland scrub conifers and the mountains catch the last
rays of the afternoon sun. However, Sargent is concerned only
with fixing on paper the apparition of trees veiled in shifting clouds
of blue smoke, as if it were merely a bank of thick fog moving
along the mountainside. There is a detachment of spirit in this
painting, which finds its closest analogy in Chinese painting, where
the elements of nature are drawn together and made one by the
vision of the artist.

Mountain Fire is one of Sargent's most abstract compositions,
relying on very little of the kind of world in which he could find
"objects" to paint. Looking at examples such as this, one somehow
questions Sargent's claim that he could not paint "views."

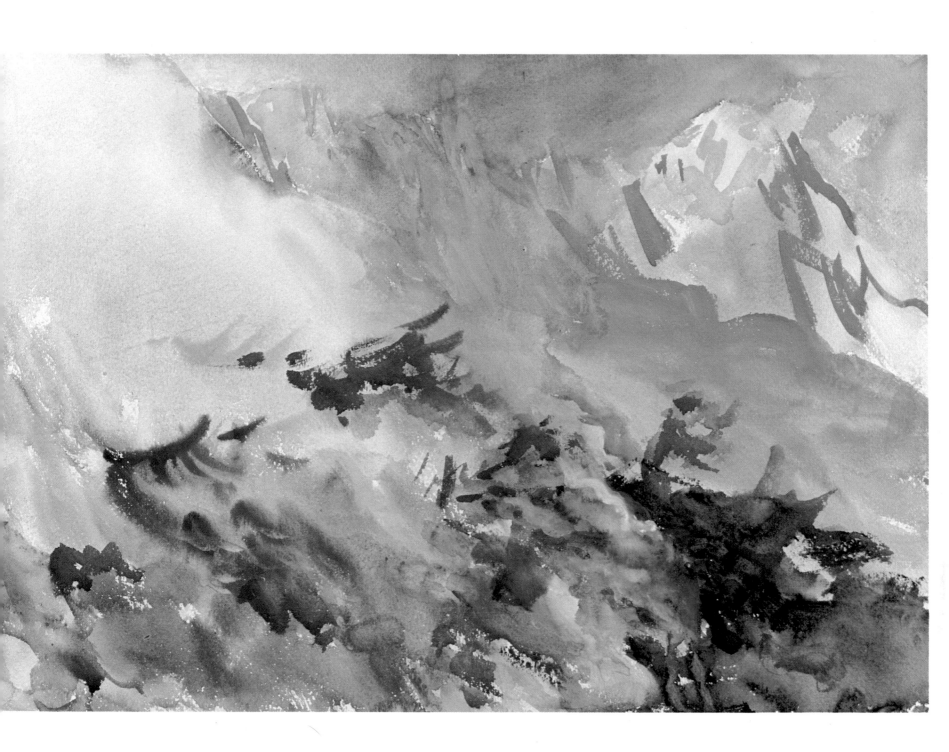

During two consecutive summers Sargent visited Rome, with excursions to Bologna in 1906, and Florence in 1907. On both trips, he produced a quantity of paintings and watercolors whose subjects tell of his intense interest in Renaissance and Baroque art and architecture. This was not an antiquarian's curiosity, but the natural result of Sargent's lifelong search for solutions to problems in art—solutions which his habit of mind caused him to look for within the tradition of Western art. To him, the world was the result of a just ordering of formal relationships. Inspiration was not simply a matter of intuition but was prompted by insights about that order.

Thus in 1907, he painted Cellini's famous Perseus in Florence's incomparable outdoor gallery, the Loggia dei Lanzi. Moreover, he painted it as few tourists have ever seen it—at night. Under the starts, dimly illuminated by the random street lights of the city square, the Perseus takes on a special mystery. Throughout his life Sargent used the words "weird, strange, fantastic" to describe things that appealed to the vein of latent romanticism in him. By day, the gardens called "Boboli," adjacent to the Palazzo Pitti, attracted him. There, behind Maria di Medici's palace, the landscaped gardens contain antique sarcophagi and Renaissance statuary situated among the avenues of cypress trees. Sargent drew the goddess Ceres, crowned in laurel and bearing a small sheaf of grain.

He crowded a full palette of color into the picture as a background for the neutral grays of the statue, which were flecked with random rays of sunshine. The balance achieved between the dominating figure and the background is so well adjusted that Sargent's free use of an almost expressionist color technique passes without seeming incongruous, either to this particular subject or to the artist's other, more traditional, use of color.

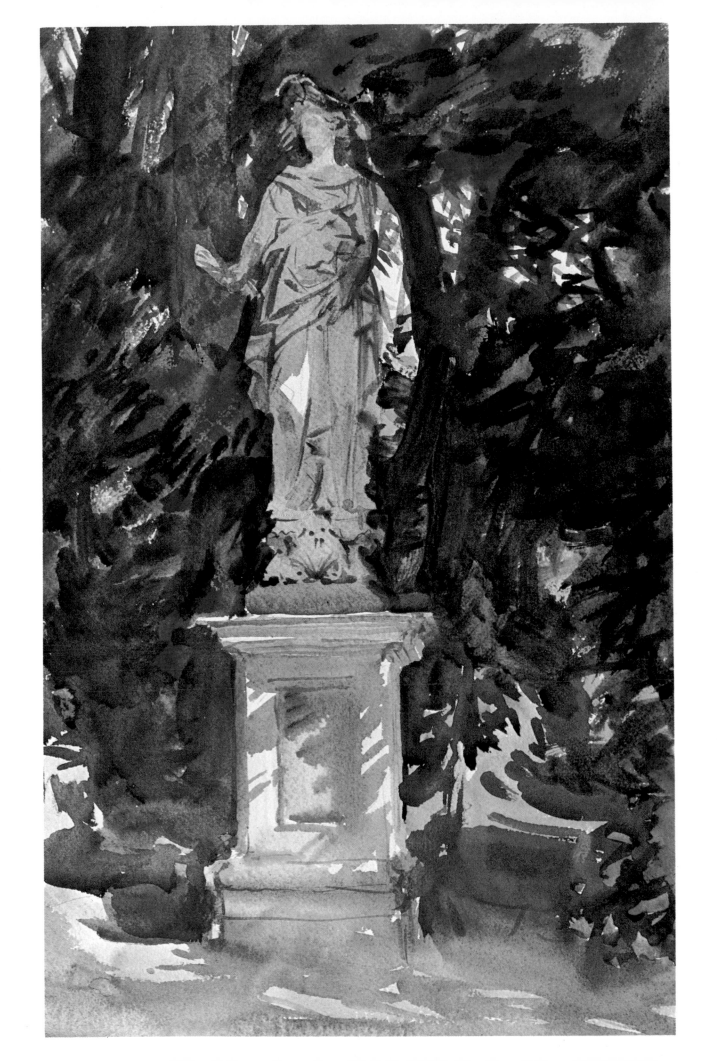

Plate 17.
BRIDGE OF SIGHS, ca. 1907
9⅞" x 13¾" (25.1 x 34.9 cm)
The Brooklyn Museum
Purchase, 1909

The Bridge of Sighs connects the Palace of the Doges and the former Venetian state prison. Its name derives from the legend that prisoners, on their way from being sentenced in the Palace to their execution in the prison, would catch their last glimpse of Venice through its small central window. Anyone who has walked along the embankment *riva* at this point quickly recognizes this as one of the standard postcard views of Venice; it is so frequently used that it has become a cliché. But Sargent has transformed it into a vision of delight, boldly stating the basic facts of the scene with a few perfectly placed strokes of the brush, combining drawing with the handling of broad masses.

His ability to make a convincing perspective without laboring the linear treatment is a marvel of simplification. The character of each of the three principal buildings is succinctly stated—the dignity of the Palace at the left, the airy and somewhat unrelated Baroque fancifulness of the Bridge, and the sombre, melancholy weight of the prison. Architectural details become rare notations in the wet wash. The whole scene is made plausible without being minutely described. Remarking on Sargent's paintings, Henry James once noted that, "...wonderfully light and fine is the touch by which the painter evokes the small Venetian realities...and keeps the whole thing free from the element of humbug which has ever attended most attempts to reproduce the idiosyncrasies of Italy."

Against the transparent washes of the background, and to balance the Bridge, Sargent has placed a group of figures in a gondola. Both the active figures of the gondoliers and the seated passengers are stated with the same economy, although, as here Sargent frequently resorted to using opaque gouache color in the manner of oil paint. In this painting the full range is employed, from the traditional purity of the medium as seen in the handling of the bridge cornice, to the impasto of the Canaletto like figures in the gondola.

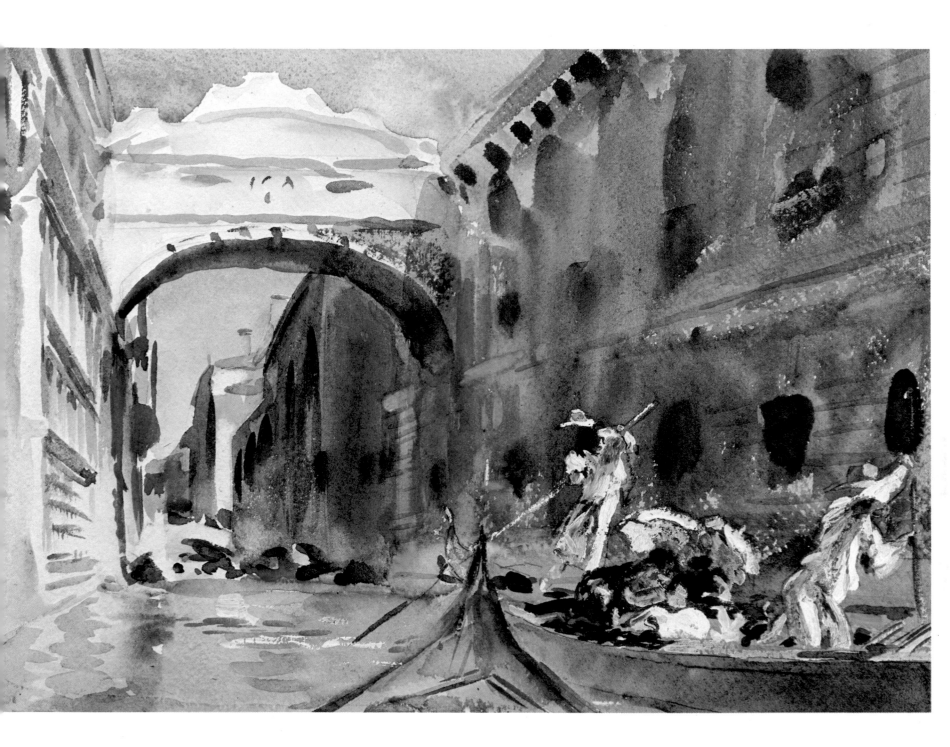

Plate 18.
ALL' AVE MARIA, ca. 1907
9¾" x 13¹³⁄₁₆" (24.7 x 35.1 cm)
The Brooklyn Museum
Purchase, 1909

Sargent himself gave the title to this watercolor for his 1909 New York exhibition. It is not a place name but, rather, a description of the hour of day when this work was created. Specifically, it refers to the time of evening vespers. The church at the left, to which the two dark figures are proceeding, is the Spirito Santo. It is located on the waterfront called Guidecca in Venice, at the point where the embankment, Zattere allo Spirito Santo, turns obliquely in the direction of the Piazza San Marco. In the distance, across the main basin of the Grand Canal, one can identify the campanile of San Giorgio Maggiore.

Sargent has set himself the task of working with a subject caught in the full light of the afternoon sun. All cast shadows are thereby obliterated, and the scene becomes one of total light. The resulting high color key requires a perfect translation to paper in order to make sense of the extremely pale blues and whites. The adjustment of the transparent blue used in the sky area, and the blues representing the planes of the buildings, is made with deceptive ease, and this little composition comes off as the quickest possible sketch. It is interesting to compare this virtuoso performance with an earlier one, such as the watercolor of Santa Maria della Salute. It is apparent that Sargent became more interested in evoking the poetic character of the scene he was painting, subordinating particular descriptive passages to effects of general impressions.

A kind of suspension of disbelief occurs here, one in which the observer of this watercolor accepts the rightness of the statement: the two black verticles *are* figures; the slashes of umber and emerald at the lower right, ripples on the surface of the water; the simple wash of blue, sky.

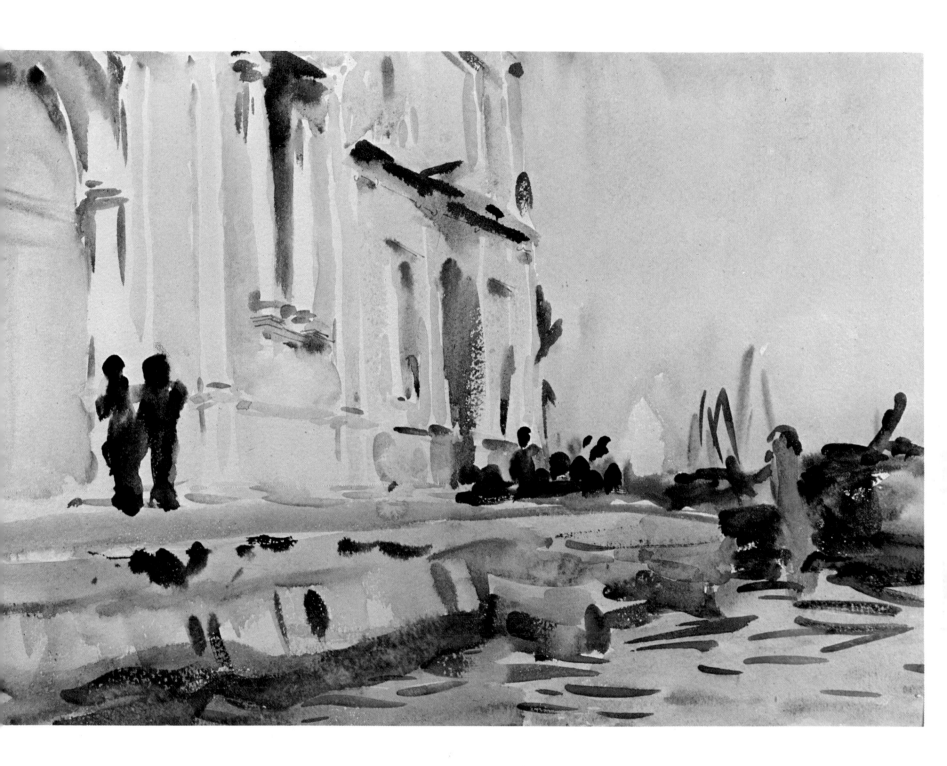

At the time of Sargent's death, among the effects in his London studio, there was a large collection of watercolor and charcoal sketches. His sister, Mrs. Francis Ormond, donated hundreds of these, principally to The Metropolitan Museum of Art and the Corcoran Gallery of Art in Washington, D.C.

The charm of Sargent's slighter works rests in their fluency of execution. Commissioned portraits or exhibition pieces often implied a self-consciousness that Sargent knew hampered his spontaneity. Painting a face, for example, might require numerous reworkings, yet the final result had to seem as if it were really made in continuity with the whole composition. Therefore, when not pressed by the requirements of public exposure, he was freer to invent new ways of resolving figure compositions.

Woman with Collie reveals Sargent's remarkable control over drawing, and his mastery of values and color. With only a few pencil lines to guide his placement of the forms, Sargent plunged into the work, using the brush in both wet and dry techniques. The suggestion of sunlight falling upon the figures is made largely through the use of white paper and transparent washes. Sargent excelled particularly in his representation of white in watercolor. This is to be noted especially in the areas where white is represented in shadow, with color imparted to it by reflected light. His color combinations suggest an unexpected modernism in the arrangements of mauve, emerald, and rose hues. There is a curious emphasis in the design of this painting. The white areas of the composition are placed in the bottom half, and they contrast abruptly with the top, which is charged with color and line.

Sargent experimented with this same idea of dividing a picture area into two contrasting, and nearly equal, halves in portraits such as *The Wyndham Sisters*, 1899 (The Metropolitan Museum of Art). Whether *Woman with Collie* represents this idea in the process of development is not known. However, this watercolor does evoke the memories of another era, with its suggestion of soft summer light and ambience of genteel comfort.

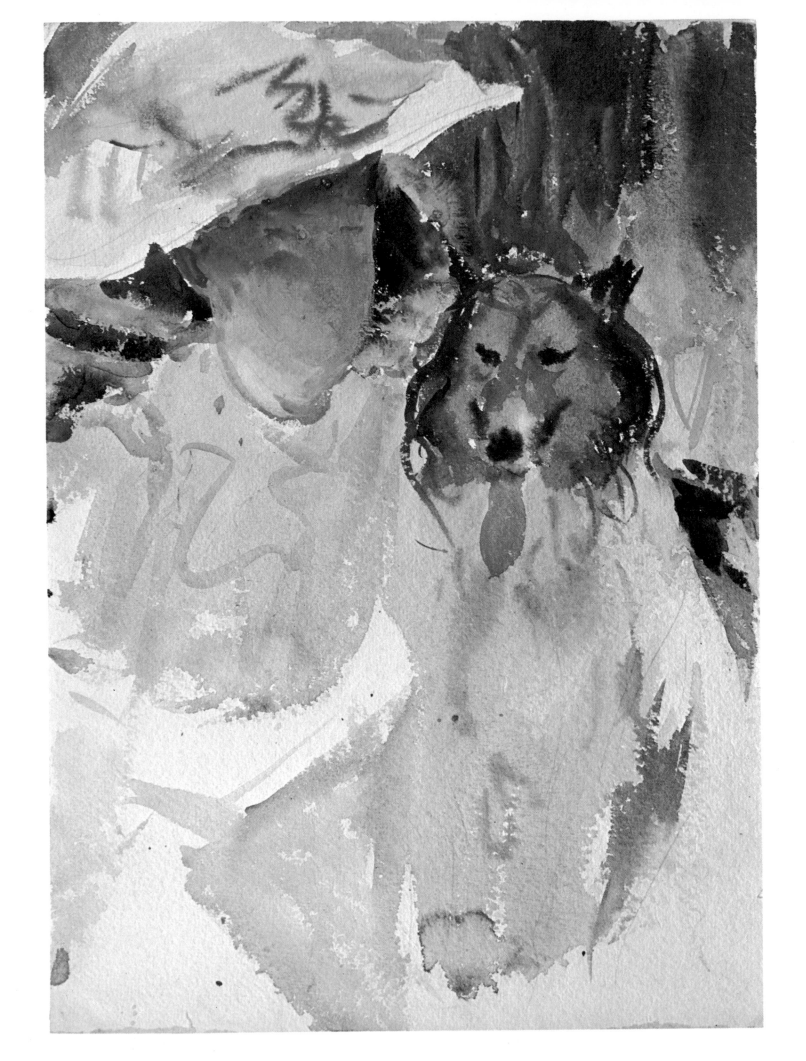

Plate 20.
GIUDECCA, ca. 1907
10" x 14" (25.4 x 35.0 cm)
The Brooklyn Museum
Purchase, 1909

The sundials of Venice are inscribed with the words *Horas non numero nisi serenas* (Count only happy hours), a motto that Sargent might have taken for his own, as far as his watercolors of the city are considered. In Sargent's time, the Guidecca canal was crowded with sailing vessels, and the quais were bordered with a forest of masts and sails. Perhaps this is the sunniest of all Sargent's Venetian watercolors, completed, as it is, almost entirely in the fluid technique called "wet in wet."

Its color is particularly lyrical: passages of gold ochre contrast with ultramarine blue; elsewhere, bold color accents enliven the composition. The drawing is accomplished entirely with color, and the staccato patterns play against the more broadly handled passages. Except for the lower portion, where a naturalistic reference is made in his treatment of the patterns of reflection in the water, this work is conceived as mass and color in a highly abstract way.

Here Sargent seemed to depart from his accustomed habit of "painting objects"; in so doing he created a work which calls to mind the atmospheric charm of the watercolors of another artist, Hercules Brabazon (1821-1906). Now largely forgotten, Brabazon was one of the most celebrated practitioners of the medium at the turn of the century. His vignette-like views of Venice especially delighted English connoisseurs, many of whom contributed to the large collection of his works at the Tate Gallery, London. Sargent never commented on the influence Brabazon may have had upon his own interest in watercolor. However, three portrait sketches of the French artist, all dated 1900, attest to Sargents friendship.

Away from the Brabazon-haunted views of Venice, Sargent reverted to his more incisive style, where the dominant interest is in the "object" rather than in atmospheric charm.

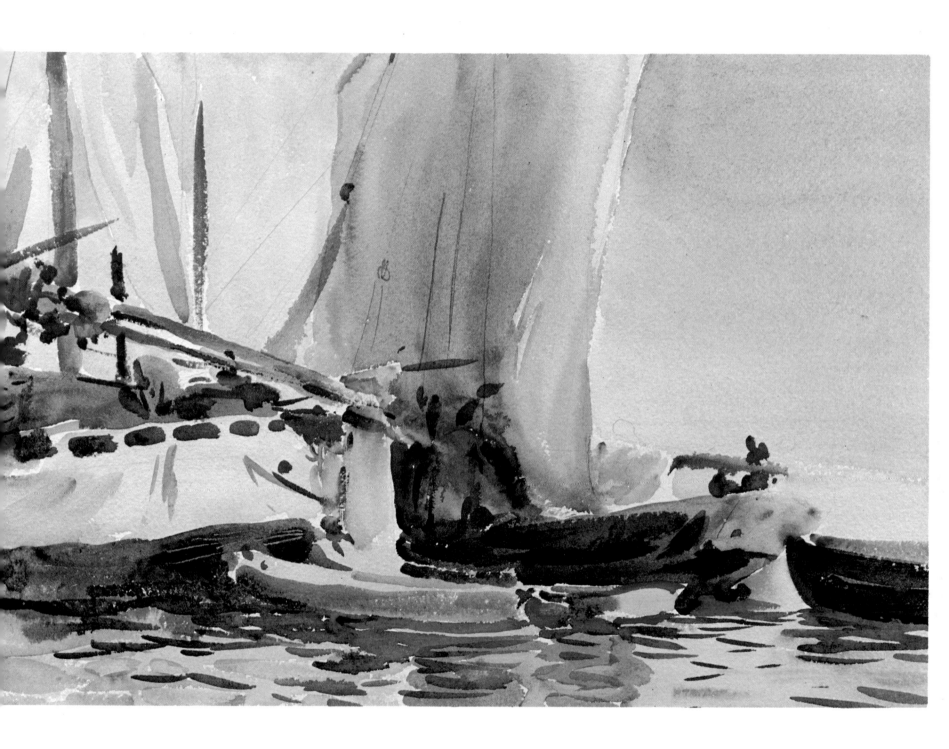

Plate 21.
WHITE SHIPS, 1908
13⁹⁄₁₆" x 19⅛" (34.4 x 48.6 cm)
The Brooklyn Museum
Purchase, 1909

From an inscription on the reverse of this watercolor we know that it was painted in Majorca, in the Balearic Islands. During the early summer of 1908, Sargent took a house at a place called Valdemosa, on the island of Majorca. From there he made trips to the island's capital, Palma, where this watercolor was probably made. This painting represents a cluster of fishing boats at mooring in the harbor. In contrast with the preceding work, it is conceived in a linear way; the strokes of color have a greater importance than the masses and forms. The result is a composition which has a nervous and staccato quality.

Sargent's interest in the non-color, white, runs throughout his work in watercolor. Some of his most important portrait commissions were also concerned with the use of white as a principal element of the color composition. White picks up and reflects nuances of all surrounding local color, thereby becoming almost limitless in its range of subtlety. In direct sunlight, white reflects warm light; in shade, it usually takes on the effects of the sky and the surrounding objects. Here, Sargent exploits the full range of possibilities inherent in the white surfaces of the boats, bathed in the strong light of the Mediterranean sun. Even the quality of the stroke varies, from the slash of the fully loaded brush, to the delicate meandering lines of pearly white, which represent sunlight bouncing from the water onto the hulls of the boats. The sails are depicted with a warm white, while the painted hulls are given the cooler white of the untouched paper.

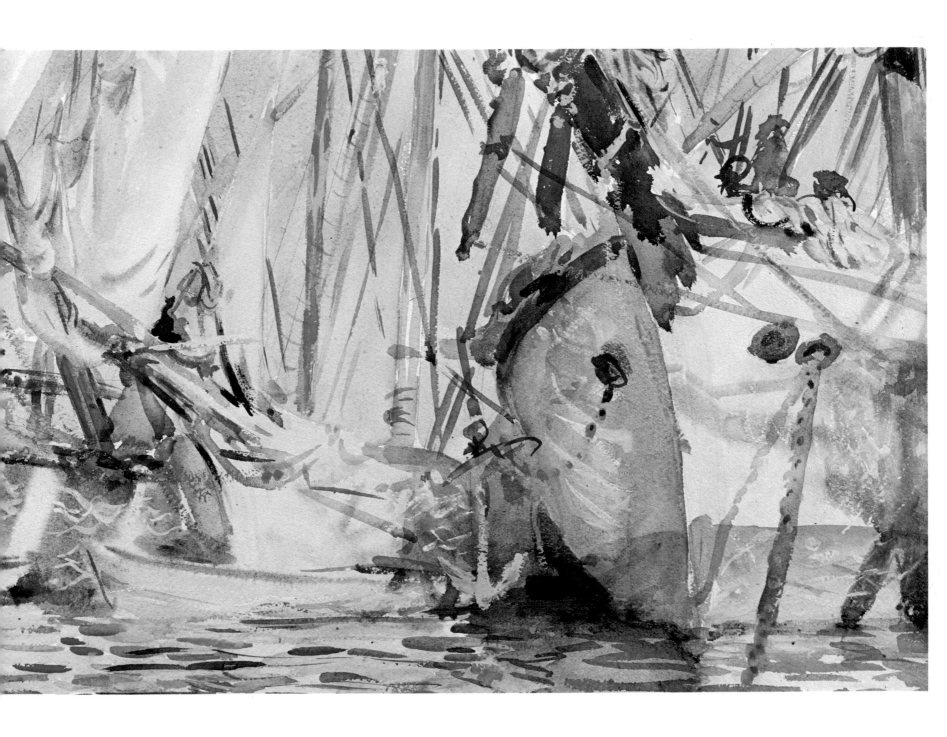

This subject was also painted on the island of Majorca. Sargent had always said that he could not paint views but was interested in objects. In this painting, the object is at once visual and symbolic. In Christian iconography, the pomegranate is the symbol of the inner unity of the Church, because of the countless seeds containd within the single fruit. But there is also a pagan mythology in which the pomegranate symbolizes the return of spring and the rejuvenation of the earth. This second idea influenced the Christian belief in immortality and the Resurrection.

During this time Sargent was committed to his expanding composition for the Boston Library decorations. Having completed the two opposing ends of his hall at the library, he still had to solve the problem of finding a suitable connective idea to link the Judaic and the Christian elements. This he did by planning a series of six lunettes, three to a side of the library hall, each side of which would amplify the Judeo-Christian theme. The central lunettes of the Christian trio are "Hell," "Judgment," and "Heaven." Their counterparts on the opposing wall are "The Fall of Gog and Magog," "Israel and the Law," and "The Messianistic Era."

It is for the latter that this watercolor seems to have been destined. At the time that Sargent painted it, he may not have known the end towards which he was working; he may have just been enjoying the opulent colors which abounded in this lush tangle of foliage. Eight years would pass between the creation of the watercolor and the final incorporation of the germinal idea in the library composition. However, comparing the two, it becomes obvious that this same group of pomegranates figure importantly in the design of the "Messianistic Era" lunette. The year 1908 was also the last one in which Sargent actively pursued a career as a portrait painter. Therefore, the pomegranates may also be seen as symbolic of Sargent's own rejuvenation as an artist. The Boston Library designs were, in his estimation, the apogee of his career.

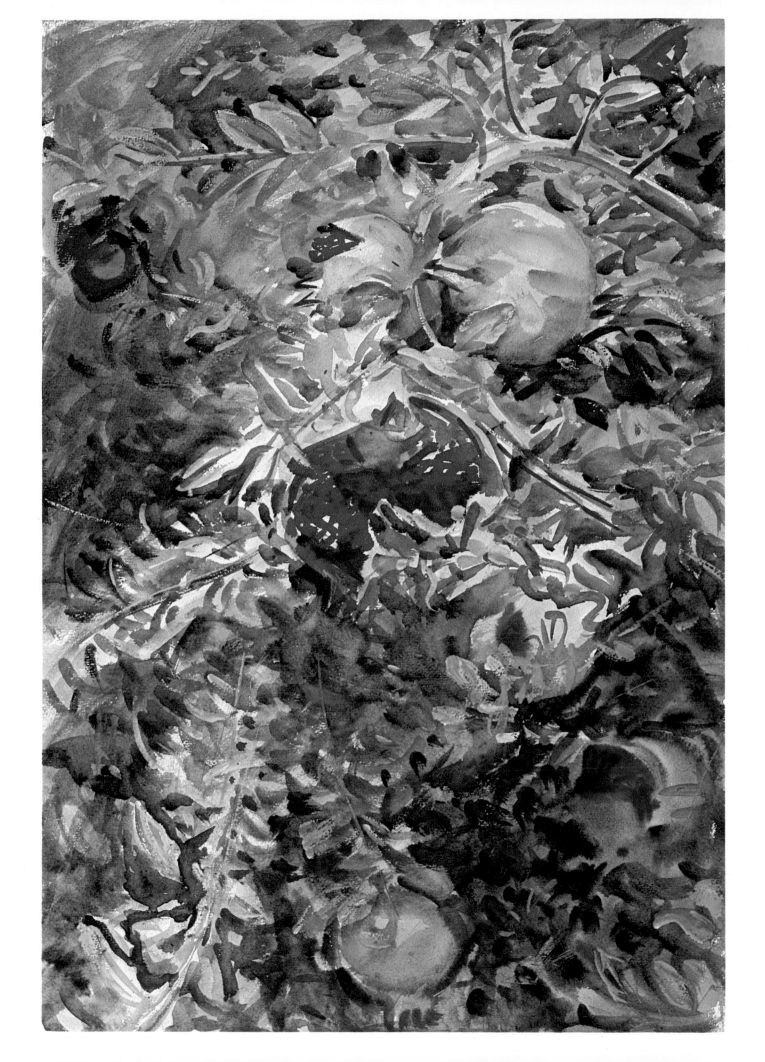

Plate 23.
IN A MEDICI VILLA, 1907
21⅛" x 14⅝" (53.7 x 37.2 cm)
The Brooklyn Museum
Purchase, 1909

Sargent seems to have had an unending appetite for the Baroque glories of Roman and Tuscan palaces. There are an uncounted number of studies in oil and watercolor of the terraces, ballustrades, porticos, and fountains of villas, such as the one owned by his friend the Marchese Torlonia at Frascati. Indeed, the record he left of the grandeur of the Villa Torlonia (destroyed in the Second World War) is a unique document. Here, in some unkown villa, he celebrates the curvilinear forms of an almost impossibly ornate fountain, whose upward limit carries the eye beyond the confines of the composition into space itself. Some ten years later, when he was painting the portrait of John D. Rockefeller at Pocantico, New York, Sargent recreated the spirit of his 1907 Medici fountain. Relaxing from the task of the portrait commission, he created an exuberant oil, whose subject was a sun drenched fountain in the gardens at Pocantico. One looks at this American version as a recognition of the splendor of the past, recreated by a modern Medici family.

The idea of selecting an architectural subject for a painting suggests the interest of the scholar, rather than that of the painter. However, Sargent elevates the subject above mere description of the forms of the fountain. There is something in the total performance that suggests an energy and a sheer delight in the phenomenon of this complex form, entirely separate from the scene itself. The simple washes of the background, with its luminous sky and its forceful cypresses, offer an effective contrast to the Carrarra white of the fountain and its golden shadows. There is something unmistakably gallant in the conception of this subject; a joyful celebration of light and form in the final years of an era that believed in the varieties of beauty and tradition.

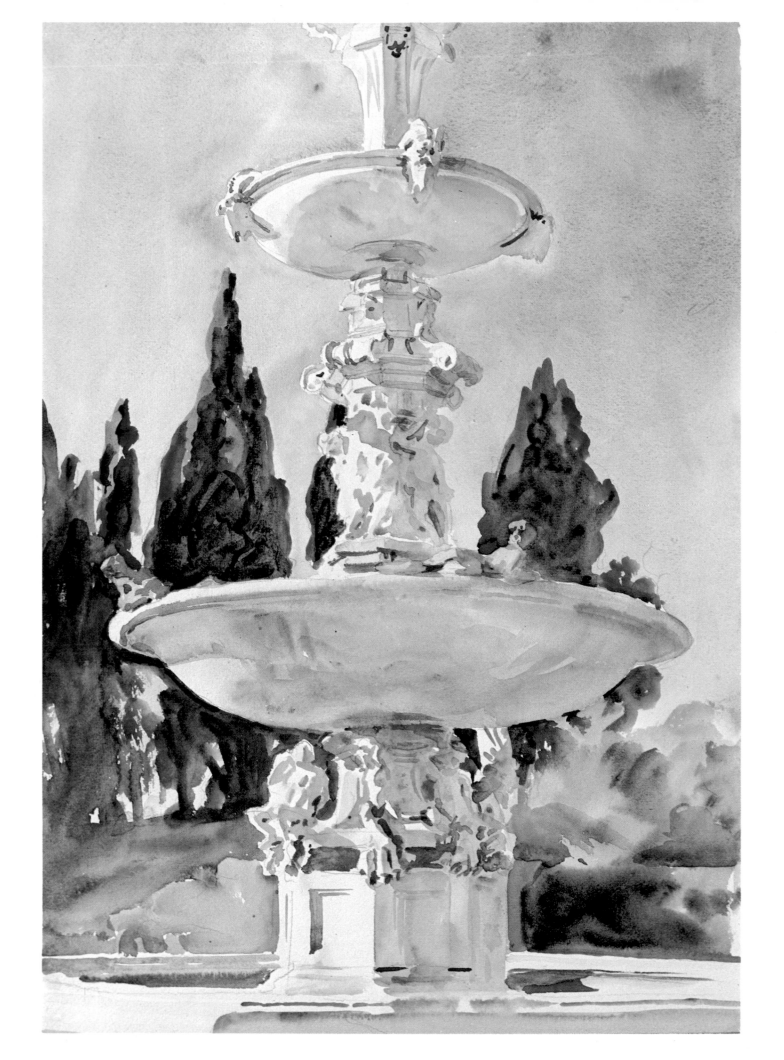

Plate 24.
MOUNTAIN STREAM, ca. 1910-12
13½" x 21" (34.3 x 53.3 cm)
The Metropolitan Museum of Art
Purchase, 1915, Pulitzer Bequest

This watercolor was made during one of Sargent's summer trips to his favorite mountain valley in the northwest corner of Italy, the Val d'Aosta. The village of Courmayeur sits at the head of the valley, through which flows the River Dora Baltea, a tributary of the Po. Although he painted many pictures here, Sargent was nearly always concerned with the details of nature, rather than with the general landscape. Except when his traveling companions could be caught off guard taking a noontime siesta, Sargent devoted his attention to a close study of the mountain streams in this area. The works executed here probably number over a hundred, both in watercolor and oil. Most often, there is no human figure represented. They are insistently impressionistic in approach; Sargent's main interest was the effects of light and shadow.

In both color and drawing, *Mountain Stream* offers a full range of interest. The upper half, with its rich juxtapositions of violet and emerald green, contrasts effectively with the muted tones of the glacial rocks in the foreground. The latter are described with great fluency, without lacking a sense of detail. Sargent, in his comments to students, stressed particularly the importance of understanding the forms in nature. He advised them always to sacrifice the obvious and easier "scene" for some special detail in which the student "worked out the forms."

It is clear that Sargent had a fondness for these Alpine streams and enjoyed painting rocks in a stream bed, where both the form and color were changed and refracted by the water that rushed over them. The inclusion of a figure here—particularly a nude one—is rare. The glowing flesh tones seem to have been included more by way of contrast with the sweep of foreground shadow, than for the sake of subject interest. An element of humor almost creeps into this particular work, especially when one remembers the formally attired athleticism of Sargent's climbing companions.

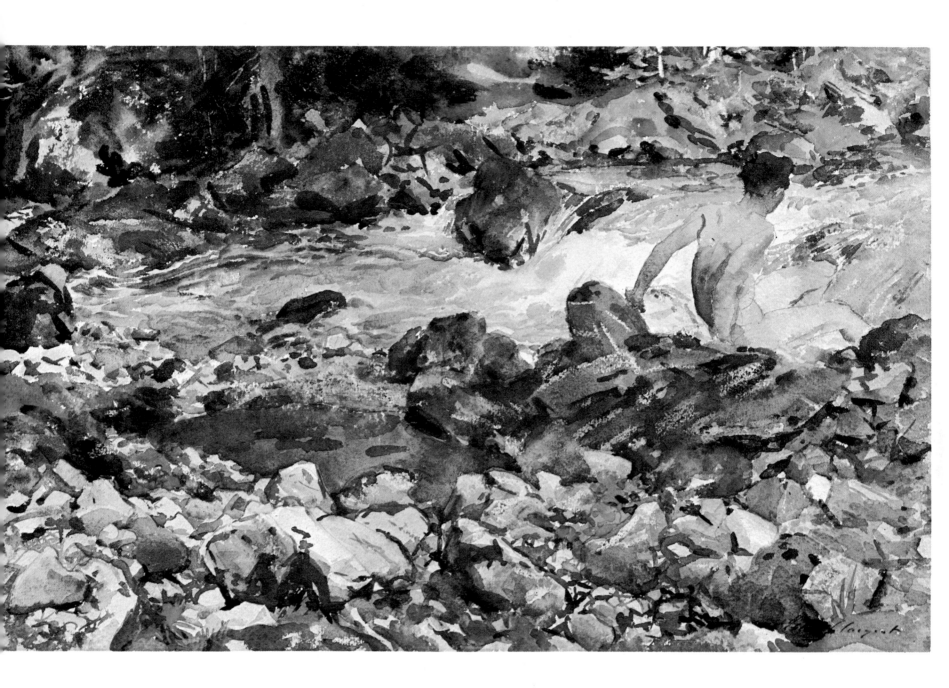

Plate 25.
GRANADA, 1912
15⅝" x 21" (39.7 x 53.3 cm)
The Metropolitan Museum of Art
Gift of Mrs. Francis Ormond, 1950

On at least three occasions, beginning in 1895, Sargent visited Spain. The second time was in June, 1903, following his trip to the United States. His final visit took place in 1912. From the record of his activities there on the last trip, Sargent found much to inspire him in Granada, and also in Aranjuez, a town some thirty miles south of Madrid. Concerning the latter, he wrote, "This place is perfectly charming, grand gardens with cavernous avenues and fountains and statues long neglected—good natured friendly people—lunch in the open air under arbours of roses."

By 1912, he had reduced his portrait painting commissions to nil, and, for the first time, he was able to consider himself simply a painter. There is an unmistakable air of gaiety in his work that year, a mood which is amply transmitted in the atmospheric *Granada* watercolor. As usual Sargent describes the broad fact of the scene with unerring accuracy: we are looking toward the northwest, from a point somewhere on the slopes of the Sierra Nevada range, which guards the city's southern flank along the Rio Genil. The time of day seems to be noon, with a pronounced haze diffusing the intense sunlight. The dark cypresses soak up the sunlight, while, in the foreground, the scene seems to indicate an abandoned olive grove. The silver gray foliage of the olive trees glows duly in contrast with the surrounding profusion of the almost chaotic color of the wildflowers and grasses.

Taken by itself, this passage alone might justify what one critic, writing in 1964, said about Sargent's watercolor technique—that it ". . . relates to certain American abstract painting more closely than do Cézanne, Picasso or even Monet." Curiously, only a year before, Sargent had published (in the English periodical, *Nation*) a somewhat guarded comment revealing his admiration for Gauguin's use of color. The suggestion of a new freedom—could it have been subconsciously prompted by the Postimpressionist movement?—is abundantly in evidence in *Granada*.

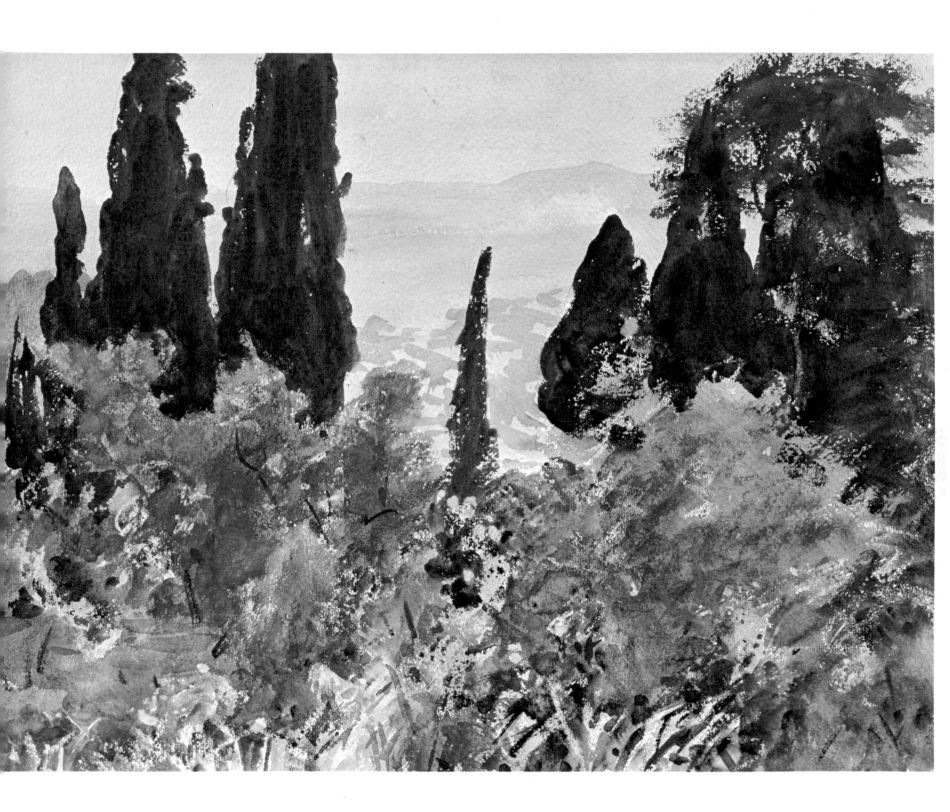

Plate 26.
IN THE GENERALIFE, 1912
14¾" x 17⅞" (37.4 x 45.4 cm)
The Metropolitan Museum of Art
Purchase, 1915, Pulitzer Bequest

The date traditionally assigned to this watercolor is 1902. However, during the summer of that year Sargent was in Norway, and no evidence of any Spanish subjects can be attributed to that period. Also, the style of *In the Generalife* is much freer in execution than any work Sargent did in the medium as early as 1902. Although he travelled in Spain and Portugal the following year, the same may be said of his production on that trip (see commentary on Plate 2). His last recorded visit to Spain was made in 1912, and it is much more plausible to ascribe *In the Generalife* to this period in his career.

The figures which occupy the center of the composition are Jane de Glehn, wife of Sargent's student, Wilfred de Glehn; his sister, Emily; and a Spanish friend, known only by her first name, Dolores. Emily is shown working on one of her watercolors. Perhaps because of her natural reticence of spirit and the intimidation which she must have felt over her brother's fame, Emily never exhibited professionally. From the evidence contained in her four watercolors now in the collection of the Museum of Fine Arts, Boston, her talent was substantial.

Although Sargent was rarely given to expressions of fantasy in his work, at the center of this watercolor there lingers a curious suggestion of something other than a mere representation of a pleasant afternoon's sketching. The oddly uptilted perspective of the pavement, the somewhat melancholy color scheme, dominated by purple and bluegreen, and the strange presentation of the faces, suggest a ritual activity. Mrs. de Glehn's detached, unworldly beauty contrasts with the ancient wisdom implicit in the face of Dolores and the vague mask of Emily. Indeed, Emily seems to symbolize a seer guided by outside, mystical, influences. Reinforcing this notion, one sees the different character of contemplation and action implicit in the related notations immediately adjacent to the two spectators' heads. Behind Mrs. de Glehn there is a veiled, out of focus, figure in the act of sketching; she is, herself, cast in an attitude of reflection. Emanating from the head of their companion, Dolores, there is a ray of agitated light, suggesting some force of vibrating energy.

To the casual observer of Sargent's art, such an interpretation may seem unduly fanciful. But no artist works purely from observation of external phenomena, and, despite Sargent's studiedly quiet life style, there was sometimes an undercurrent of mysticism evident in his art. Spain, from the beginning, had excited his inclination toward the "strange, weird and fantastic." On the basis of this, it seems facile to ascribe the strength of this work to mere proficiency of technique.

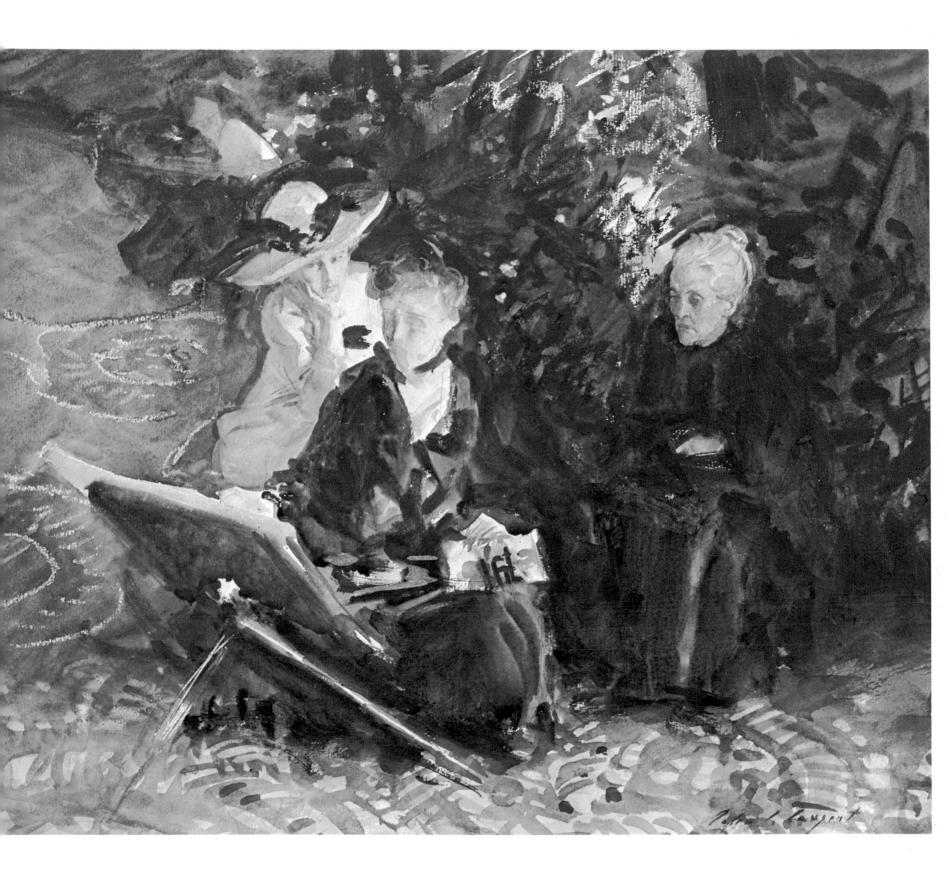

Plate 27.
ESCUTCHEON OF CHARLES V, 1912
11⅞" x 17¾" (29.8 x 45.1 cm)
The Metropolitan Museum of Art
Purchase, 1915, Pulitzer Bequest

In the garden of the Generalife Palace in Granada there is a wall ornamented by the coat of arms of Charles V, the first Hapsburg to rule over Spain. His reign began in 1519, and the decoration dates from the first half of the 16th century. At the time of Sargent's visit to Granada in 1912, he was busily engaged in the completion of a suite of designs for six lunettes in the Boston Public Library. The basic shape of the escutcheon relates, of course, to that project, although the heraldic formality of the Hapsburg arms could not possibly offer Sargent any suggestions for the treatment of his figurative compositions. The Library project required, however, that Sargent consider the need for keeping his figures subordinate to the shallow architectural space of the lunette. The raking light which Sargent observed playing across the bas-relief of the escutcheon may have offered him a parallel: three dimensional form could be modified to adjust to the essentially flat orientation of the lunette shape; it could be modified in a way that preserved both the integrity of Sargent's representational paintings and that of McKim's architecture.

Although this watercolor is conceived in terms of the strictest dialogue between warm and cool colors in blue and tan, Sargent elicits from these seemingly meagre resources one of the most brilliant performances of his career. There is a constant play throughout the painting between sharply focused details and broad washes. The watercolor is a remarkable performance in drawing, yet it never descends to the academic idea of a "rendering." It reminds one that Sargent was capable of being visually stimulated where others might find only the ordinary.

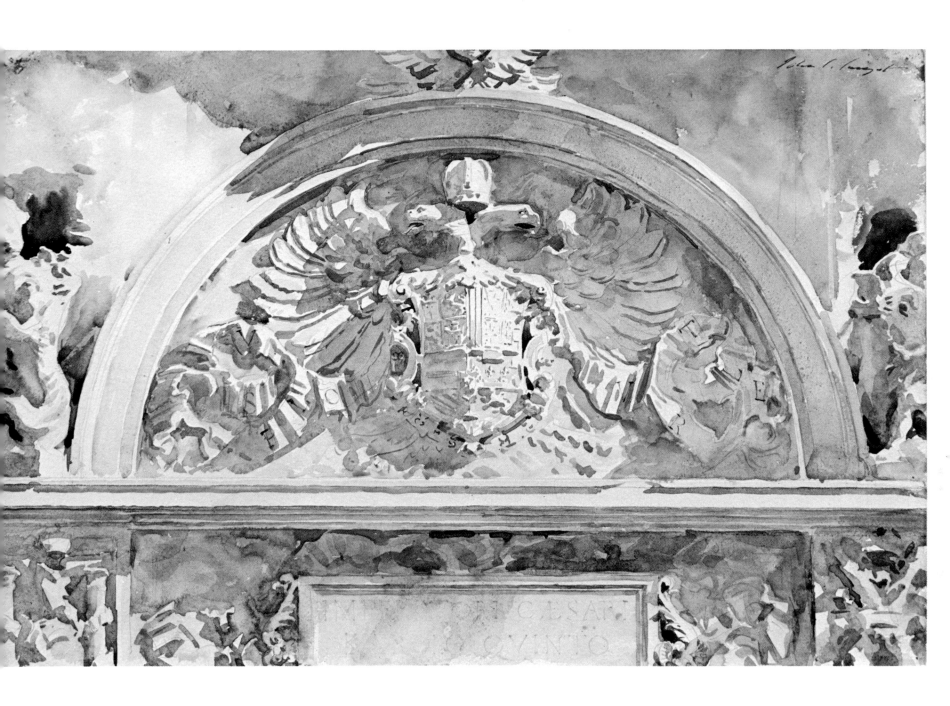

One of the subjects most frequently found in the work of Sargent executed on summer holiday in the Swiss and Austrian Alps is the carved and painted local crucifix. Although he was not an outwardly religious man, the crucifix had a profound meaning to Sargent, a meaning that was at the heart of his grand design for the Boston Library. Indeed, he had sought advice from Augustus St. Gaudens (1848-1907), on the problems of modeling a bas-relief crucifix for that design. When the final mural was installed in the Library in 1903, it was apparent that Sargent had added an innovation to the iconography of Christian art. In addition to the usual presentation of the Christ figure, Sargent included the figures of Adam and Eve. A version of the same group serves as a memorial to Sargent in the crypt of St. Paul's Cathedral, London.

Perhaps the Alpine versions of the Crucifixion appealed to Sargent because their anonymous creators also tended to conceive of the symbol with the same stark intensity that Sargent was to give to the one in Boston. Especially in the paintings executed that final summer in the Tyrol, at the outbreak of the war in 1914, Sargent chose to reiterate this motif, emphasizing an atmosphere of gloom and foreboding. These pictures seem to be the visual equivalents of Henry James's vision of their epoch "slipping over the abyss." Intimations of James's prophesy can be found in *Tyrolese Crucifix*, in spite of its bright color. Composed as a "snapshot," as the passer-by glances up at the roadside shrine, the painting has almost a casual grace. Nevertheless the emphasis upon the gnarled and leafless tree, and the dislocation of the entire composition from any relationship with its environment, underlines the artist's preoccupation with the instability of his world.

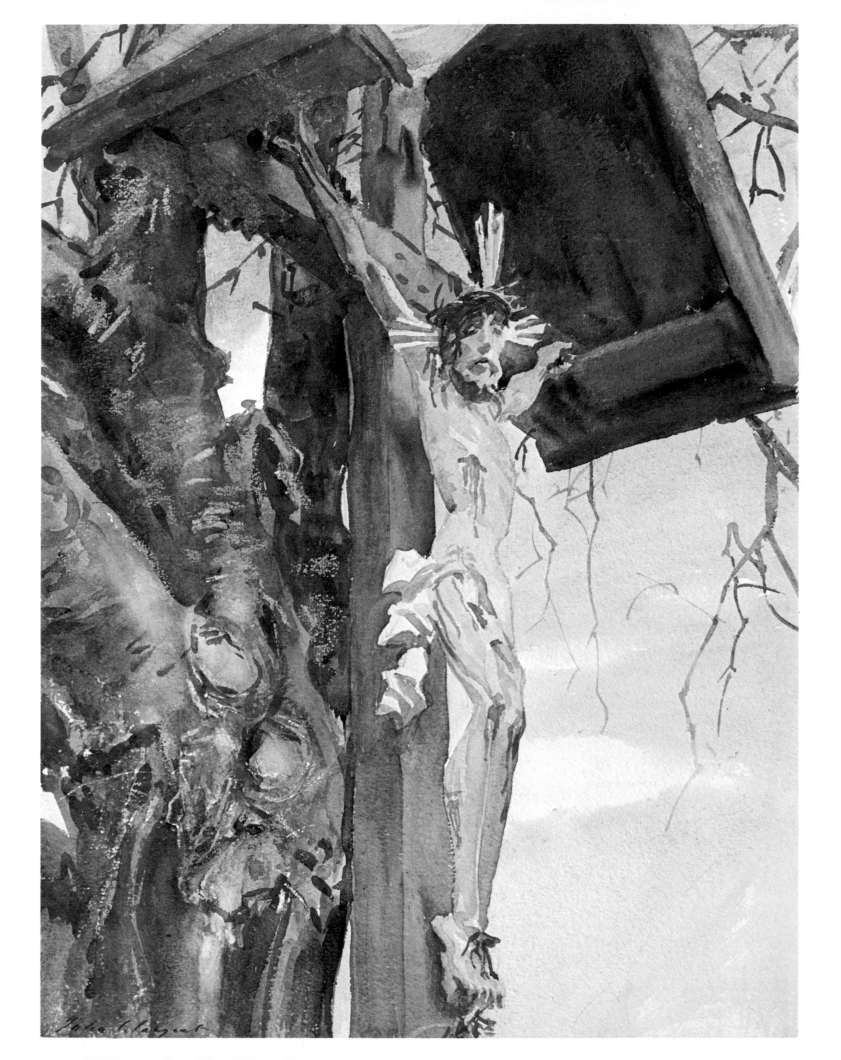

In May, 1916, Sargent returned to Boston to install further portions of his Library decorations. The summer became particularly oppressive, and he was eager to escape to the mountains. His old friend, the artist and teacher Denman Ross (1853-1935) encouraged him to visit the far west. A camping expedition was planned, and Sargent fled to British Columbia, by way of Montana, assisted by his studio factotum, Nicola d'Inverno, and a guide.

Sargent experienced a surprising sense of adventure in the unaccustomed rustic living. Taking temporary comfort at a hotel in Field, B.C., he wrote to a friend in Boston, ". . . it was raining and snowing, my tent flooded, mushrooms sprouting from my boots, porcupines taking shelter in my clothes, canned food always fried . . . and a fine waterfall which was the attraction of the place pounding and thundering all night. It takes time to learn how to be really happy."

Sargent was not fond of the discomforts of camping, and for a man who was unused to much physical exercise, he showed a cheerful persistence in the quest of subjects to paint. He made one large oil out of the trip, *Lake O'Hara* (Fogg Museum of Art, Cambridge), which rivals Albert Bierstadt's earlier achievements on canvas, encompassing the grandeur of the American west. But, mainly, Sargent's attention was riveted upon the details of camp life and not the broad landscapes. It has been noted that Sargent's British Columbia watercolors are more subdued than any of his other work in the medium. He was responding to the wild and rough aspects of nature in the western mountains; the color is cooler and his manipulations are more forceful and bold.

In *Camp at Lake O'Hara*, the trees in the background are laid in with simple manipulations of the loaded brush. The manner of the strokes would be almost brutal, had they not the easy assurance of Sargent's masterly shorthand. The white of the canvas of the tents offered him yet another opportunity to exercise his fondness for working out the forms of this elusive color which subtly reflect the adjacent local colors. The suggestion of these tents in a shaded clearing, illuminated by the broad blue sky, is reinforced by the casual notation of the mountain in the distance, bathed in sunlight.

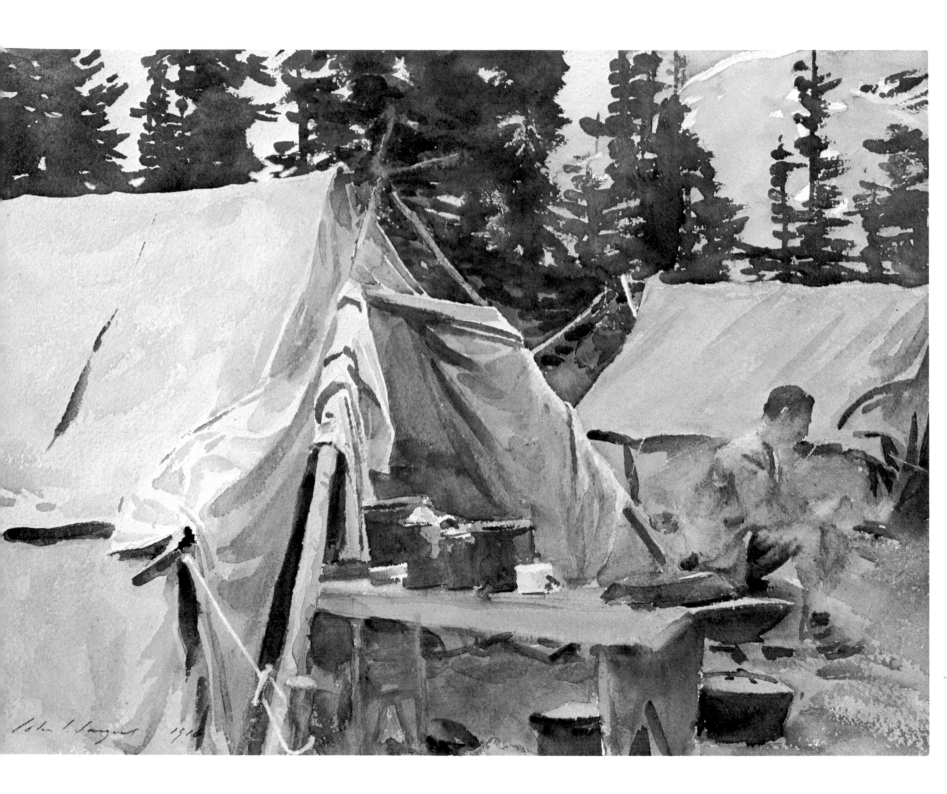

The occasion for Sargent's presence in Florida, in the spring of 1917, was a portrait to be painted for the benefit of the Red Cross. The subject was John D. Rockefeller, who was spending the season at Ormond Beach. This brilliant and penetrating portrait of the wizened financier was achieved years after Sargent had resolved to paint no more "mugs," as he had come to think of his sitters. The success of the Rockefeller portrait may have been the result of the happy circumstance by which Sargent found himself in this immensely agreeable tropical place, named, coincidentally, "Ormond Beach." (Sargent was devoted to his sister, Mrs. Francis Ormond, and to her children, Rose Marie and Reine, who posed in many of his sunfilled Alpine watercolors and oils.)

Finishing the Rockefeller portrait, Sargent stayed on in Florida for a few weeks as the guest of Charles Deering. Deering's industrialist brother, James, was building a pleasure dome at Brickell Point called Vizcaya. Recalling those vanished summers in the Mediterranean sun, Sargent said of Vizcaya: "It combines Venice and Frascati and Aranjuez and all that one is likely to see again." This was Sargent's last look at paradise, before returning to Europe and the war.

The Florida watercolors were parting shots that precipitated favorable critical comparison with Winslow Homer's art and resulted in a large exhibition at the Carnegie Institute in Pittsburgh, in November 1917. However, Homer looked upon the rich colors and textures of the tropics with different eyes; he had struggled with his stoic New England temperament and his watercolors seem to withhold an emotional response. Sargent, on the other hand, plunges into these Florida subjects with the abandon of one who had no difficulty indulging himself in such pleasures.

At the same time, his American heritage did break through the layers of required European culture from time to time, in comments such as "I am fiddling and doing watercolors while Rome is burning and easing my conscience by doing a portrait of Rockefeller for the Red Cross." But this did not deter Sargent from painting exotic sights with obvious relish: alligators basking in the sun, and the splendors of Vizcaya, with all of its baroque architectural improbabilities. The watercolors glow and live with a power that perhaps even Sargent did not suspect of himself. The real glory of Sargent's Florida watercolors are the dozens of sensitive studies of palms. He seems to have poured the full force of his resources of observation into these paintings, capturing at once the complex symmetry of his subject, and the very mood of the tropics.

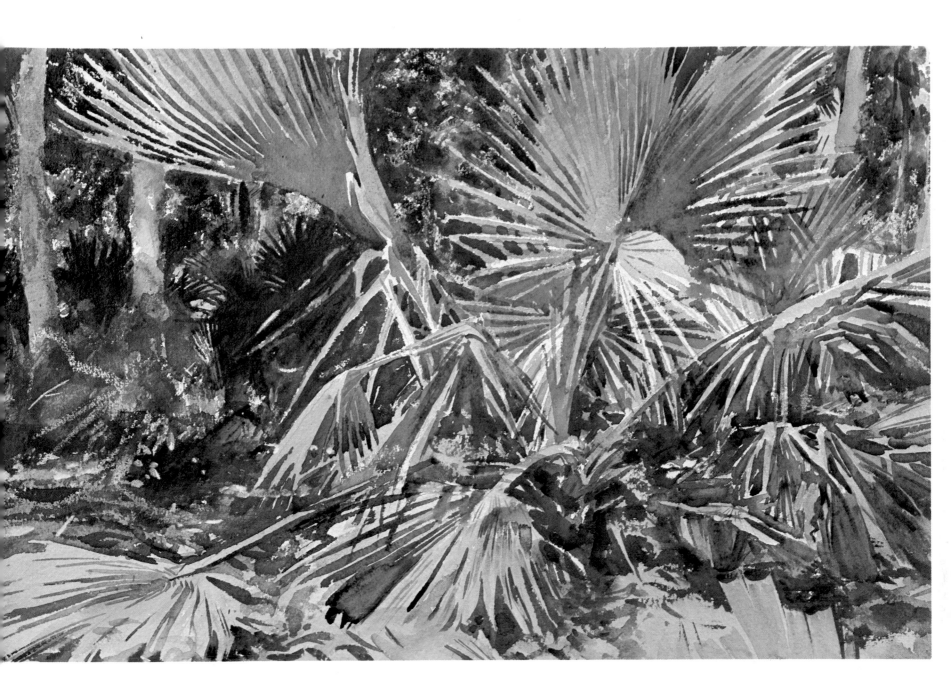

Plate 31.
FIGURE AND POOL, 1917
13¾" x 21" (34.9 x 53.3 cm)
The Metropolitan Museum of Art
Gift of Mrs. Francis Ormond, 1950

Sargent had long opposed the position of "painters to whom the name Post-Impressionists can be applied." He viewed the rise of this new movement as something "that the sharp picture dealers invented and boomed" as a "new article of commerce." The Edwardian era, an era which Sargent's portraits so ably mirror, ended both in symbol and in fact with the death of the King in 1910. That world of order that the Edwardian way of life characterized claimed Sargent's deepest persuasions as an artist: "If one had oneself under perfect control, one could always paint a thing. . . ." Yet, Sargent could admire Gauguin's use of color while lamenting the quality of the Frenchman's drawing. Sargent's loyalties lay with the past, with the realism of Manet, and that of the early Impressionists.

How strange it is then, to discover a picture like *Figure and Pool*. It has been noted that the tropics exerted a profound change within Winslow Homer. And so with Sargent. The same release seems to have occurred, if only for a moment in the afternoon of his life. He had been working from life models in Boston that winter of 1916-17, but the results were decidedly traditional, in keeping with the scheme for his newest project to decorate the rotunda in the Museum of Fine Arts, Boston. In Florida, where he could discover untried subjects like alligators and palm trees, his imagination seems to have been completely freed from all restraints. *Figure and Pool* reveals a pure passion for light and color that clearly overcomes forty years of habit. It is almost as if his one remaining reservation about Gauguin had been erased. In fact, Sargent goes even farther here, intimating the future directions which were taken by the Expressionists.

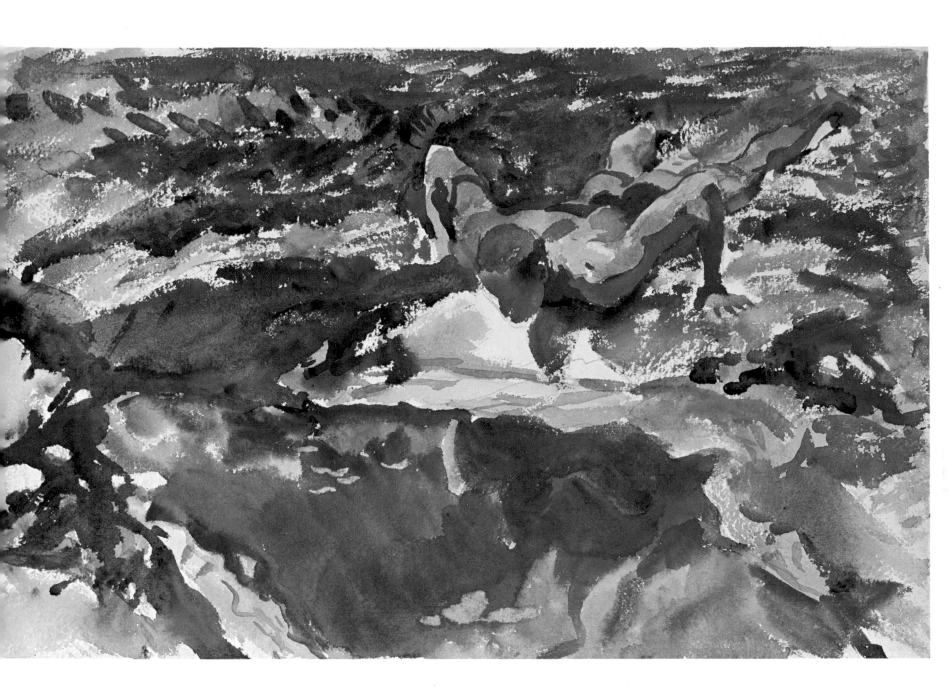

Plate 32.
DUGOUT, 1918
15⅜" x 20⅞" (39.0 x 53.0 cm)
The Metropolitan Museum of Art
Gift of Mrs. Francis Ormond, 1950

In May, 1918, Sargent received a letter from Lloyd George, the English Prime Minister, asking him to participate in a project which would require Sargent to travel to the war zone. The idea was to create a large painting which would commemorate the joint efforts of British and American troops in the Great War. This was a unique experience for a man like Sargent who throughout his life had steadfastly refused to read daily newspapers. He was sufficiently innocent to ask a general whether or not the fighting was discontinued on Sundays.

In July, 1918, he was with the English "Guards Division" near Arras, living in an "iron hut" to avoid bombs. Through all this Sargent was reported to be in high spirits, riding in the new tanks with his friend Philip Sassoon, and dominating the conversation at mess time. His subject was ever elusive, however. "How can there be anything flagrant enough for a picture when Mars and Venus are miles apart whether in camps or in front trenches. . . . The Ministry of Information expects an epic—how can one do an epic without masses of men?" The battlefield was little more than an empty landscape, the participants hidden in trenches, and the villages largely in ruins.

Sargent's cheerfulness gradually departed, and he began making a series of sombre sketches, reflecting the desolation around him. The "epic" picture was achieved, finally, in a huge frieze like composition entitled *Gassed* (The Imperial War Museum, London). Its subject was, as Sargent described it in a letter, ". . . a harrowing sight, a field full of gassed and blindfolded men."

The unfinished watercolor *Dugout* carries the same mood of desolation, the suggestion of pale sunlight reinforcing the sense of weariness and futility characteristic of Sargent's war sketches.

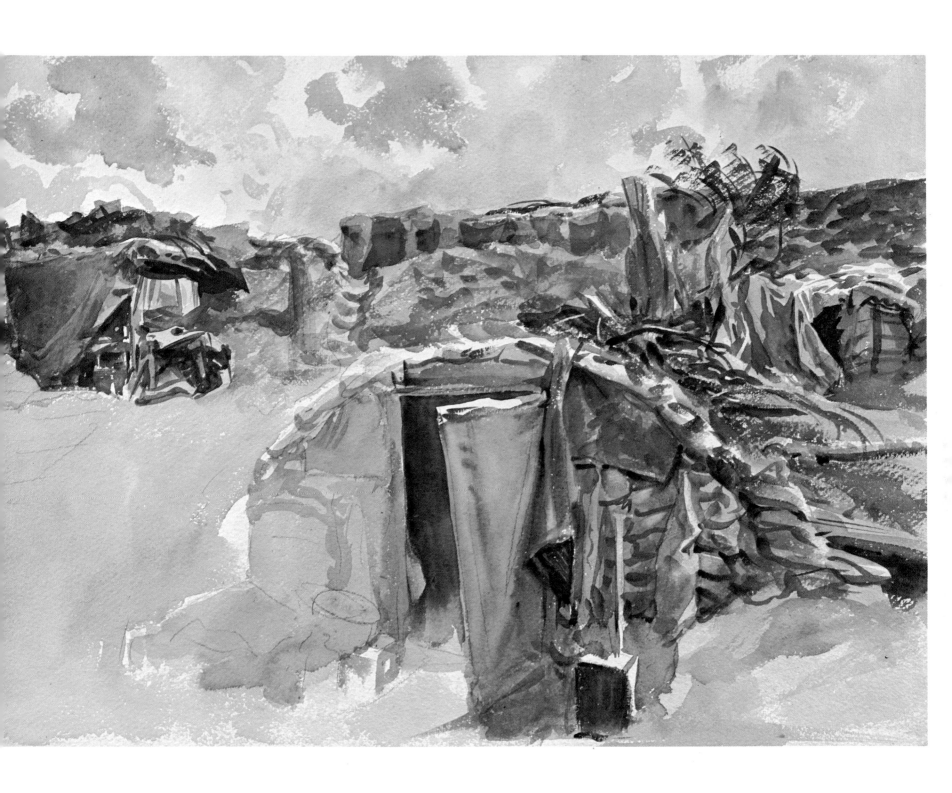

INDEX

Edited by Heather Meredith
Design by James Craig
Graphic Production by Frank DeLuca